The Campus History Series

UNIVERSITY OF CENTRAL FLORIDA

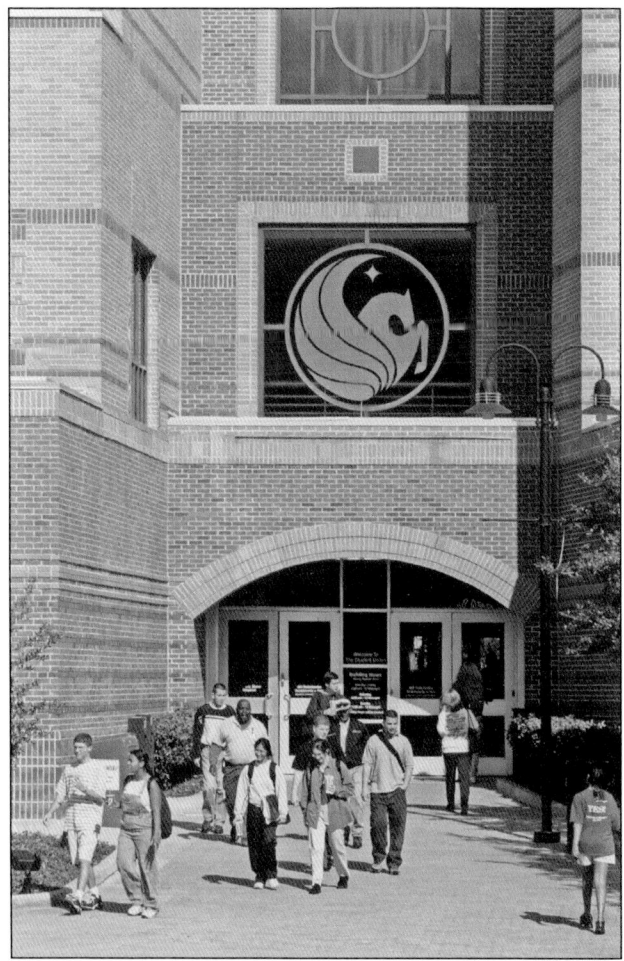

The Student Union stands in the geographic center of the University of Central Florida campus, surrounded by concentric circles of sidewalks and roads, a gateway between the historic Florida Tech campus and the modern UCF campus. Its completion in 1997, after more than a decade of student lobbying and environmental and construction delays, signaled an era of growth during which UCF transformed from a tiny regional campus into one of the largest campus communities in the nation. (Courtesy of the University of Central Florida.)

ON THE COVER: The O-Team, composed of student leaders from across campus, has long been a University of Central Florida tradition. Pictured on the cover is the 1978 O-Team, posing in the old campus Village Center in the final year that an orientation would be held for Florida Technical University (FTU) before the school's name changed to University of Central Florida (UCF). (Courtesy Orientation Office.)

BACKGROUND: In the university's early years, the Reflecting Pond was drained for graduation ceremonies, but explosive growth throughout the 1970s required administrators to rethink standing traditions. When Lee R. Scherer, director of the Kennedy Space Center, spoke at the June 10, 1978, commencement, more than 5,500 guests came to watch, marking the final graduation at the pond. The next graduation ceremonies, each larger than the last, would be held across campus, first outside the Humanities and Fine Arts Building, then the Education Gym, and now the UCF Arena. (Courtesy of the University Archives.)

The Campus History Series

UNIVERSITY OF CENTRAL FLORIDA

NATHAN HOLIC AND THE UCF ALUMNI ASSOCIATION

ARCADIA
PUBLISHING

Copyright © 2009 by Nathan Holic and the UCF Alumni Association
ISBN 978-0-7385-6768-6

Published by Arcadia Publishing
Charleston, South Carolina

Printed in the United States of America

Library of Congress Catalog Card Number: 2009920589

For all general information contact Arcadia Publishing at:
Telephone 843-853-2070
Fax 843-853-0044
E-mail sales@arcadiapublishing.com
For customer service and orders:
Toll-Free 1-888-313-2665

Visit us on the Internet at www.arcadiapublishing.com

*For my wife Heather, my brother Jason,
and our entire UCF family*

CONTENTS

Acknowledgments		6
Introduction		7
1.	The Rural Space University	11
2.	Florida Technological University	27
3.	The Village Center: The First Two Decades of Student Life	39
4.	UCF: The Transition Years	53
5.	A Campus Outgrown	69
6.	Pegasus Circle: Gateway to the 2000s	81
7.	Student Life at UCF	93
8.	The Athletic Village	109

ACKNOWLEDGMENTS

Just as the University of Central Florida was a community effort from the start, this book was made possible only through the generosity of its alumni, students, and supporters, who supplied the images and reflections that (hopefully) make this book a rich account of a four-decade shared experience. Judith Beale at the University Archives deserves special recognition for finding many of the most dynamic images contained herein; she is a tireless historian, always searching for more photographs and memorabilia to build the university's collection. Tom Messina and Judy Creel, at the UCF Alumni Association, were also instrumental in ensuring that this book saw publication.

While this book is indebted to the four decades of newsletters, bulletins, and articles over which I pored, I also owe special thanks to those UCF family members, past and present, who agreed to be interviewed or contributed material, including Roy Reid, Christa Santos, Dr. Frank Rohter, Don Jonas, Michael O'Shaugnessy, Michelle Romard Milczanowski, Joe Maclellan, Bryan Farris, Joe Ritchie, Lloyd Woosley, Linda Tomlinson, Joe Hornstein, and Jason Holic, among others. Thank you, also, to my wife, Heather, and my editor, Lindsay Harris, for their patience and understanding, and to the Coca-Cola Company for the tens of thousands of ounces of Diet Coke that kept me going.

Unless otherwise noted, all photographs are courtesy of the Special Collections and University Archives Department, University of Central Florida Libraries (Orlando, Florida). Photographs marked with UCFAA are courtesy of the UCF Alumni Association, photographs marked with UCF are courtesy of the University of Central Florida, photographs marked with Orientation Office are courtesy of the UCF Orientation Office, and photographs marked with Athletics are courtesy of UCF Athletics.

INTRODUCTION

By 2008, University of Central Florida enrollment hit an all-time high of 50,254 students, placing it as the sixth largest university in the United States, a remarkable feat for a school celebrating just 40 years of classes. In the years immediately preceding this accomplishment, each college at the university had grown in enrollment, too, but several colleges had split into two distinct units, and many other academic programs had been formed from scratch at a breakneck pace: in a 10-year span, the university grew from 5 colleges to 12, the Rosen College of Hospitality Management opened, the College of Medicine broke ground, and the College of Optics and Photonics became the first such school in the nation. Countless new buildings had been constructed to accommodate such growth, including the groundwork for an entire medical campus in nearby Lake Nona, a hospitality campus near International Drive, several new engineering and business complexes, and an entire new campus of academic structures bordering a grassy Memory Mall, not to mention an on-campus football stadium and basketball arena and so many new residence halls that few freshmen would now worry about securing on-campus housing.

And all of this had been finished according to a master plan that saw the campus easily contained within a single circular roadway, keeping every academic and student service building within walking distance, with shuttles employed for residence halls and off-campus apartments. Yes, the university had become gigantic, but it was also far from the bustle of downtown Orlando, safe in a corner of the city it had carved itself and still with plenty of land preserved for natural wetlands and forests.

In short, UCF had fashioned itself into one of the most well-planned and efficient major metropolitan universities ever, a campus of antique brick halls, Mediterranean apartments, and sleek high-tech research centers all coexisting easily, built at the edge of a metro area bursting at the seams with growth and excitement. Forty years after its first classes were held in a single building in the middle of the woods, all seemed complete. But considering the school's earliest hours, marked by determination and vision but precious little funding, such a future could not have been even the remotest of fantasies.

Orlando, Florida, at the start of the second half of the 20th century, was, for all its charm, barely a player in southeastern politics. Its downtown was quaint, consisting mostly of department stores and modest office buildings, and its appeal for out-of-state travelers and tourists relied heavily on attractions that today elicit little of the same enthusiasm displayed for Disney World or Universal Studios: natural wonders and camping grounds that dotted the thick interior-Florida landscape from Kissimmee to Sanford. These were tin can tourist

days, when the roadways allowed no easy access to towns in the muddy, mosquito-filled heart of the Florida peninsula; major highways were still reserved for the coastlines. Central Florida was land best suited for agriculture, and indeed the citrus industry—after advances in pasteurization techniques in the early 20th century and the advent of concentrated orange juice in the 1940s and 1950s—made the region a fine place to grow. But this was not Miami, a bustling and diverse population at the nation's southernmost tip, nor was this Jacksonville, Tampa, or Pensacola, all accessible coastal cities. Orlando had its role in these days, certainly, but that role in no way resembled the position of influence it was soon to take, as this was a city stuck in the state's swampy center.

In 1957, though, the Florida Turnpike opened, connecting Northwest Florida to the Southeast, sweeping through both Ocala and Orlando on its concrete journey southward, promising both cities—and dozens more in the state's interior—a shot at retaining relevance well into the next century. Next came Interstate 4, an equally massive highway project designed to bridge Tampa on Florida's Gulf Coast with Daytona Beach on the Atlantic. Though there ensued a great deal of behind-the-scenes battling and public posturing (the *Orlando Evening Star* newspaper, and particularly publisher Martin Andersen, was one of the biggest movers and shakers involved in negotiating I-4's planned route), the highway's path was laid directly through the center of Orlando, neatly hugging the downtown district.

The placement of both highways put Orlando at a crossroads, or more appropriately, at the center of a bull's eye . . . for when Walt Disney was in the process of selecting the site for his planned theme park world, deciding amongst sites as varied as St. Louis and Ocala, he looked out the window from his seat in a private plane and saw a concrete X thousands of feet below, the meeting point of two great new highways surrounded by thousands of acres of swampland and forest, of inexpensive palmetto scrub and mud. Orlando, he decided, would be home to his Walt Disney World.

This was 1963.

Orlando's history would be forever altered in that single moment inside Walt Disney's plane, as a set of decisions were set into motion, and Walt Disney purchased the swamp, drained it in all the right spots, laid his roads, erected Cinderella's Castle and (later) the golf-ball shaped Spaceship Earth of EPCOT Center, and bestowed upon Orlando the blessing and the challenge of becoming a major international metropolitan area. In the years that followed, the modest downtown would be joined by skyscrapers, and an impressive strip of restaurants, hotels, and convention centers would blossom along the banks of I-4 on the now-famous International Drive. A city had been willed into prominence with a single decision.

But Walt Disney's was not the only world birthed in 1963. With less fanfare, though not without extreme political and cultural ramifications, another stretch of rural Central Florida was being considered for a different sort of planned community: a research university, one that many years after Walt Disney officially put Orlando on the map would eventually fulfill Orlando's claim as an influential American city.

If Disney World would make Orlando a destination, the brand-new campus of Florida Technological University, still only a whisper of an idea after final approval on June 10, 1963, would solidify the area's importance in science and research, in culture, in defense, and finally, 45 years after the school's founding, in medicine.

And the groundwork for all of this occurred in a matter of months.

This was 1963: a year in which the University of Central Florida and Walt Disney World both leapt from dream to reality. It was a year that forever changed Orlando. Like the cities of centuries past whose fortunes and populations had been built upon a quick confluence of chance and speculation, from railroads to gold rushes, from the stockyards of Chicago to the auto industry of Detroit, Orlando had assumed an identity, made possible entirely by the independent but eerily similar (and eerily simultaneous) development of a world-famous theme park and a world-famous university.

But to truly understand the history of this school, one must also understand the Central Florida community of the mid-20th century. In its earliest hours, the University of Central Florida was only one of three names put forth for consideration for a new state university to be erected in the rural outskirts of East Orange Country, Florida, and for 13 years, the school had another name entirely: Florida Technological University. The late 1950s and early 1960s had seen a boom in prosperity, optimism, and technology across the country, but more specifically, this era saw the Central Florida region redefined in the burgeoning years of the space age. The Martin Company, a prominent aerospace and defense company (later to become Lockheed Martin), had just placed their new facilities in Central Florida in 1956, and NASA's development of Cape Canaveral on the Atlantic Coast truly gained momentum in 1962. An area previously known for agriculture was now planting seeds for what would become known as the I-4 High-Tech Corridor, a stretch of engineering, electronics, optics, simulation, and biotech firms running from Daytona on the east, through Orlando, and all the way to Tampa on the Gulf Coast. This was the future of Florida, many thought then: space exploration, high technology, and defense. So it was only natural that—with Florida's population booming and these new companies offering high-tech job opportunities—any new university considered for the Central Florida region would be shaped by the community's interest in technology and space.

Florida, in these early days of air-conditioning, when suddenly the land was not just livable but comfortable and northern families were relocating down south en masse, certainly had reason to be excited about the future. But the state's higher education system was massively under prepared to handle the expected population boom. In 1955, forecasts called for college applications to state universities alone to exceed 125,000 by 1975, and Florida had only three state universities: the University of Florida, Florida State University, and Florida A&M University. So the legislature voted to establish new universities across the state, primarily in major metropolitan areas, where growth would occur the fastest.

The result, over the next two decades, was the establishment of the University of North Florida in Jacksonville, the University of West Florida in Pensacola, Florida International University in Miami, Florida Atlantic University in Boca Raton, and the University of South Florida in Tampa. Under separate leadership, each would grow into a university that would strengthen its region, and there would be no official tiered system demarcating each institution's importance (as in California). Each school's destiny was in the hands of its leaders.

But while the metro areas for other universities seemed clearly identified, the location of the state university in the Central Florida region was initially uncertain. The region was composed of many mid-sized communities, from Winter Park to Maitland to Sanford, and even Melbourne and Daytona Beach (coastal cities still identified as Central Florida). While Orlando was the center of gravity around which all others were balanced, when the state legislature passed Bill No. 125 on June 10, 1963, authorizing the establishment of a new state university, the vague language offered no assurance that Orlando would see the school within its city limits. It narrowed the location only to the east-central part of Florida, a broad expanse of land including Flagler, Orange, Seminole, Lake, Brevard, Volusia, Osceola, Indian River, and St. Lucie Counties. In the early days of planning, then, the most important problem for lawmakers and administrators to solve was that of location. A new university was approved, but where would it be built?

In much the same fashion as Walt Disney's strategic decision on November 22, 1963, when he chose a spot ripe for tourist travel, the official site chosen for the still-unnamed university would be several miles removed from the busy business district of Orlando, but also in a location prime for growth, easily navigable: 2 miles north of Florida Highway 50, which led both to downtown Orlando and toward the Atlantic Coast. Years later, roadway expansion and city planning would make this decision seem brilliantly prescient. Two major highways would see construction in the 1980s and 1990s, with the 408 East-West Expressway linking

this easternmost part of the county with downtown Orlando and the 417 toll road connecting the university with the Orlando International Airport.

The chosen land, selected on January 24, 1964, against finalists on South Orange Blossom Trail and in Seminole County, was called the Adamucci site, named for Atlantic City contractor Frank Adamucci, and initially comprised 715 acres. Quickly, it was expanded to 1,227 total acres, with William E. Davis and A. T. Mackay offering their own property to provide the university with frontage on Alafaya Trail, which connected to Highway 50. Adamucci donated half of his land with the promise that the county would pay $1,000 per acre for the other half. Things seemed as if they were proceeding smoothly, but despite Adamucci's donation, the county declared that it had no money to purchase the lands. The state legislature advised the university to wait until more state funds became available, a frustrating refrain that would continue to haunt the young university for years to come: all the promise in the world, but no money to achieve it.

But in 1965, eighty-nine Orange County citizens responded decisively. Unwilling to wait and unwilling to let the dream flounder, together they raised nearly $1 million to purchase the land and provide for planning costs. With the Citizen's National Bank of Orlando acting as trustee, each citizen was assured that their investment would be repaid, but this move was quite risky at the time: with the state budget so volatile and ever leaner, it was not unimaginable that the university might still be relocated or scrapped indefinitely, in which case the money would have been forever lost.

Years later, community members would be able to look back upon this moment, after the thousands of acres were secured and developed, the school a physical reality, the money repaid, and know the reward was worth the risk. Orange County and Orlando would be able to say that this was a groundswell moment for the university: it confirmed the promise of what had previously been paper legislation. The university was now literally and symbolically tied to Central Florida, for better or worse, and unlike some colleges and universities constructed in the remote wilderness, hours from a state's major population centers, the community had nurtured this school in its infancy and assured its survival; when state funding came up short, it was the growing community that stood up, made possible the impossible, and asserted its desire to have a major center of education and research in its backyard. It was the citizens of Orange County who decided the school's (and the city's) future. If poor funding would be a running theme for Florida Tech and UCF, so would be the resolve and dedication of the Central Florida community to see this school succeed.

It was only appropriate, then, that the university's first master plan mirrored both the sprawling makeup of Central Florida itself and the initial plans for EPCOT Center and Walt Disney World. The campus would be a series of interlocking villages, each with a specific theme that then formed a unique campus community as a whole. It is with this idea as its guide that this book moves forward, with each chronological chapter focusing upon a different thematic village in one of the largest universities in the country, to showcase the school's—and the city of Orlando's—four-decade rise to prominence.

One

THE RURAL SPACE UNIVERSITY

To understand how such a large and powerful university arrived so quickly and with such authority, one must first revisit the school's humble origins as a patchwork of undeveloped Florida swamp and pine forests in the mid-1960s.

In its early years, there were dozens of dissenting ideas about the new state university's academic direction. By 1965, the community had invested in an idea, a sparkling mid-century dream of a space university. But quickly, ideas were altering as reality took hold, the sparkle of the dream world fading upon waking: Dr. J. Broward Culpepper, executive director of the state board of education, stated publicly that a space university should not be the school's main focus, that the state most needed programs in liberal arts and business administration. And William Dial, who was appointed to represent the university on the Council of Presidents, downplayed the space university idea, declaring that the public was just caught up in the romance of missilery. But in an era when a new technological gift seemed to be unwrapped daily, from weapons to space travel, administrators and citizens alike seemed to have a vision for a school pulled straight out of the *Jetsons* (the school's first handbook even featured a cartoon character called the Citronaut, which looked curiously like a Hanna-Barbara creation), though the school would be asked to meet many other needs.

Still, the new state university would be defined in its infancy as a space university. Even a quick survey of the university's promotional materials of the time reveals a fascination with space, from the slogan, "Reach for the Stars," to an opening page of the university's first class catalog in 1967, featuring a rocket launching into space, and a message from first president Charles Millican declaring that "this generation has a rendezvous with the stars . . . We must set our course and move forward."

For better or worse, the space university had been born.

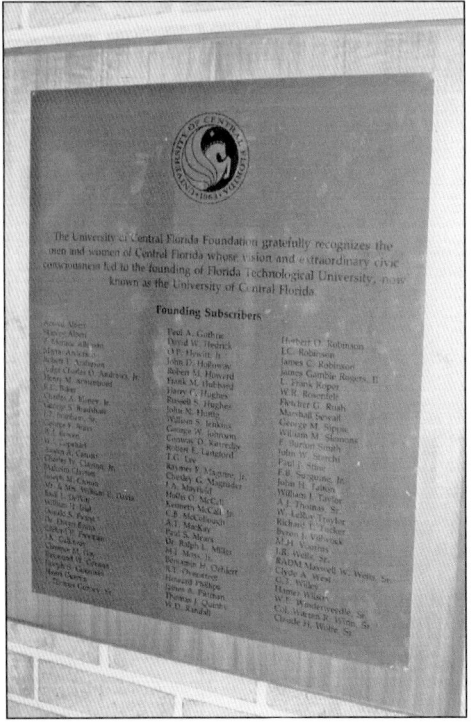

ADAMUCCI SITE, 1964. The uncleared property (named the Adamucci site after donor Frank Adamucci), full of shortleaf pine, scrub oaks, palmettos, sandy fields, and numerous lakes and swamps, would stay undeveloped for several years after its purchase, as each year the necessary state funding for construction was slashed.

UNIVERSITY FOUNDERS, 1965. In 1965, eighty-nine citizens of Orange County raised nearly $1 million to secure the purchase of the land for the new university in Central Florida. A plaque, now displayed in Millican Hall, was dedicated to these founders of the university in 1990. (Courtesy UCFAA.)

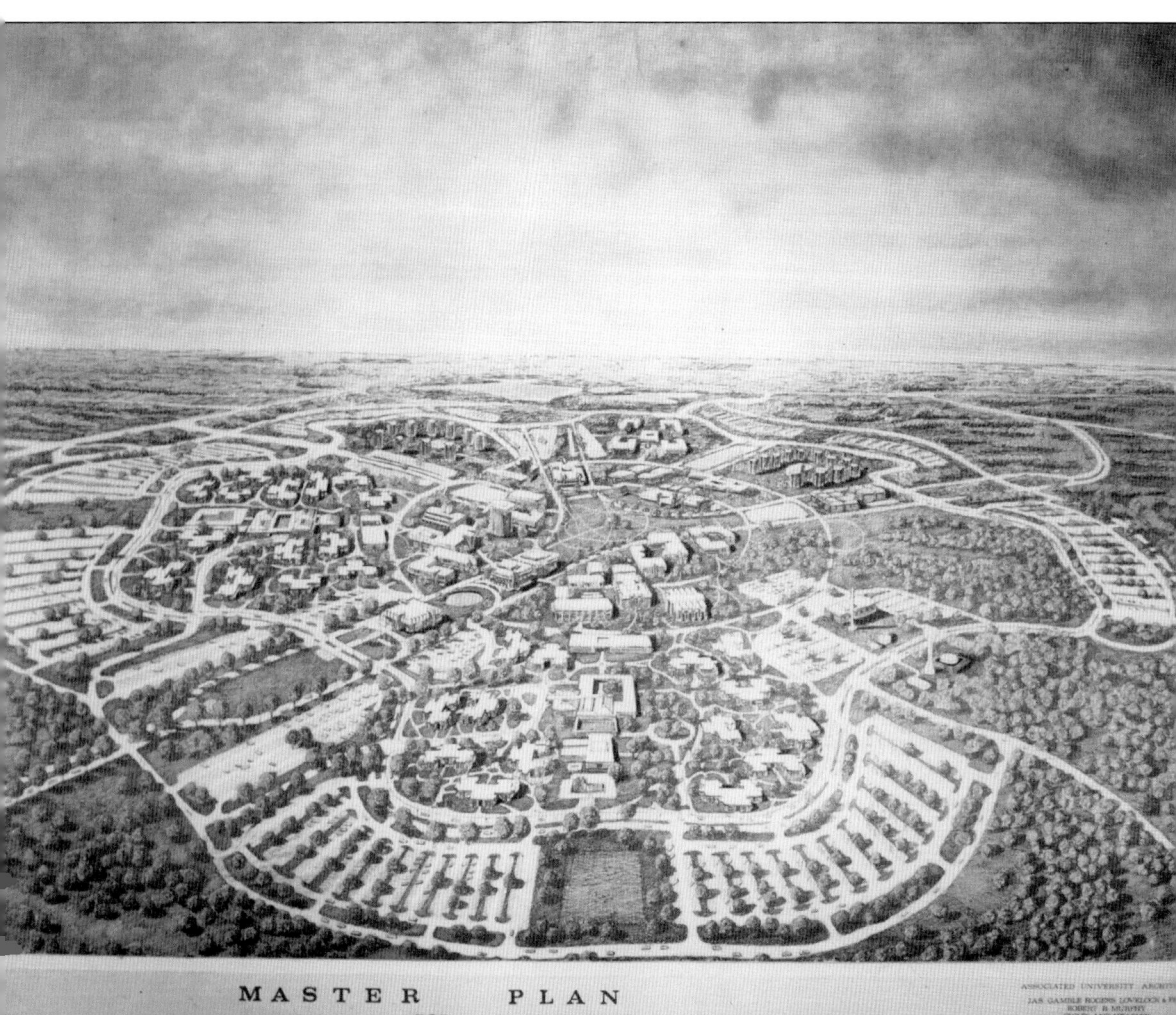

MASTER PLAN, 1965. The original master plan of the university, released in March 1965, had two objectives. First, due to an erratic state budget ($11 million had been promised for construction in order to open the school for 1,500 students by 1968, but only $7 million was granted, a shortfall that prevented offices, buildings, and even parking lots from completion), the first campus buildings would need to be multipurpose in nature. The second objective for the master plan was the now-famous village concept. Much like Walt Disney's Experimental Prototype Community of Tomorrow (EPCOT Center, still on the drawing boards in the mid-1960s), FTU would feature five different villages, each one connecting to the next in a large circular layout, surrounding academic buildings in the center and making it easy to walk from dorm to class. The villages would also allow a large university (expected growth predicted over 10,000 by 1975) to be broken apart manageably, maintaining a small school atmosphere.

Charles Millican, 1965. For all the community involvement and excitement in the early years, the Adamucci site was still just dirt, swamps, and trees. Someone would have to get to work clearing the land and quickly, because the first classes were planned (finished campus or not) for 1968. Absolutely pivotal during the crunch time of 1965–1968 was the appointment on October 19, 1965, of Dr. Charles N. Millican, the university's first president. An Arkansas native, and the former dean of the College of Business at the University of South Florida (just an hour away in Tampa and older than FTU by less than a decade), Millican set out to ensure that the university would open on schedule. He also helped to develop the guiding academic philosophy for the school, an "Accent on the Individual." From the start, Millican wanted to ensure that this institution would not be a bureaucratic business, but a school encouraging individual growth both academic and social.

ACCENT ON THE INDIVIDUAL

FLORIDA TECHNOLOGICAL UNIVERSITY

FTU, 1966. "The New State University in East Central Florida," as this letter indicates, was a flexible concept in its early years. But the community wanted a school focused on high technology and on engineering. Even the *Orlando Sentinel Star* offered editorials in defense of the space-minded focus, declaring that "a name reflecting this focus" would stand the test of time. It was inevitable, then, that a citizen's advisory committee in late 1965, after recommending the names University of Central Florida, Florida Central University, and Central Florida University, saw all three names rejected by the board of regents in favor of the geographically neutral but discipline-specific Florida Technological University. And with much hope for a technology-enriched future, this name was approved on January 31, 1966, and the school's first era began.

> The New State University in Central Florida — ORLANDO
> National Office Building, Suite 301
> One West Church Street
> Orlando, Florida 32801
>
> January 21, 1966
>
> The Honorable Wm. H. Roundtree
> P. O. Box 226
> Cocoa, Florida
>
> Dear Mr. Roundtree:
>
> You are invited and urged to attend a meeting with members of the Name Committee of the Citizens Advisory Board, the state representatives and senators of Brevard, Indian River Orange, Osceola, Seminole and Volusia counties, Dr. Louis Murray and Mr. Woodrow Darden of the Board of Regents, and myself at 11:00 a.m., on Tuesday, January 25, 1966, in the Alligator Room on the third floor of the Orlando Area Chamber of Commerce.
>
> This is a very important meeting for the purpose of re-evaluating a name for the new university in Central Florida. We realize this is relatively short notice but we want to try to expedite action on an official name. It will not last more than an hour.
>
> Sincerely,
>
> Charles N. Millican
> President

CHURCH STREET, 1965. President Millican officially opened the university's first administrative offices on December 1, 1965, operating not from the wilderness of the Adamucci site, but out of an office in the First National Bank Building at 1 West Church Street, a temporary downtown Orlando location until campus facilities were completed.

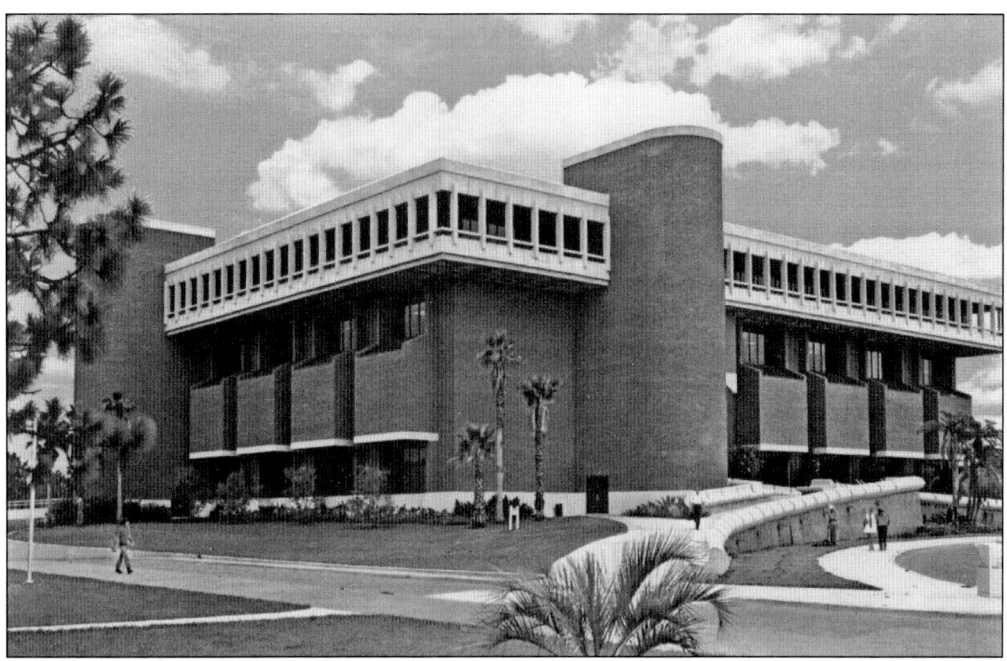

BRICK CAMPUS, 1967. With a president in place, finally the community could see progress. The faintest traces of the master plan were coming to life at the Adamucci site in East Orange County. In early 1967, the official brick—among more than 30 samples—was selected for the buildings' facades: antique colonial red. While a simple decision, this proved a major aesthetic milestone for a school built in the late 1960s, when campuses across the country (especially directional schools) sprang up overnight in low-cost cinder-block boxes. Florida Technological University, despite suffering the same economic constraints affecting these other colleges, avoided the look of budget-crunch cheapness by utilizing powerful brick exteriors designed to stand the test of time and multipurpose interiors designed to house many different offices at once until new buildings were finished. The above postcard shows the freshly constructed library, and below is a postcard of the first dormitories, supporting just over 400 students.

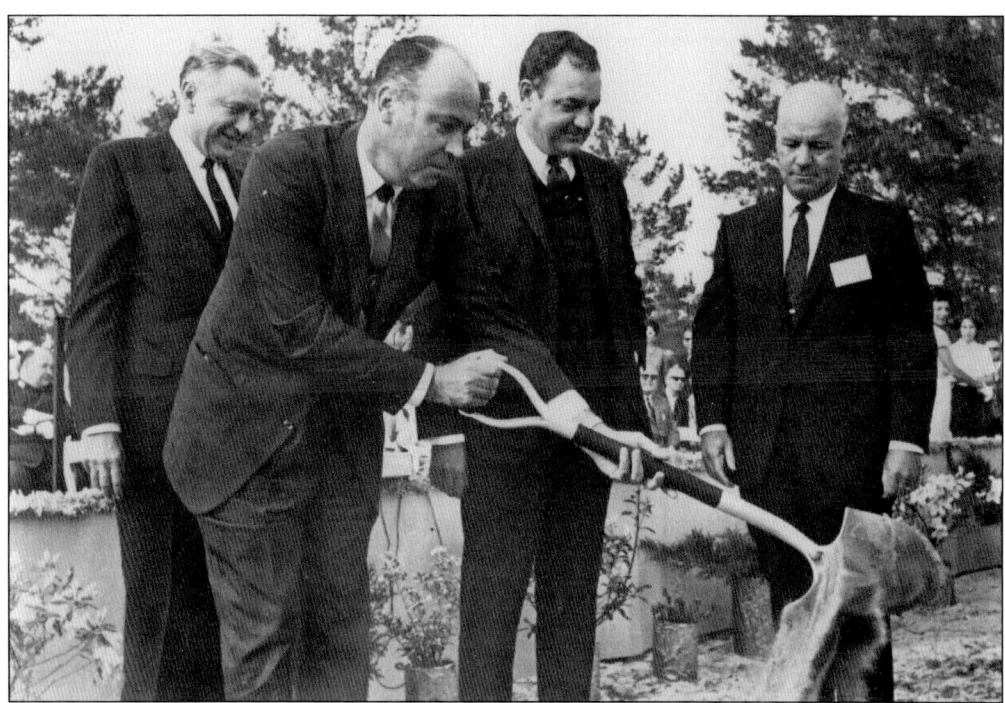

GROUNDBREAKING CEREMONY, 1967. More than 2,000 people attended the groundbreaking ceremonies for Florida Technological University on March 19, 1967. In order to prepare for the start of classes, however, the initial groundwork had already begun two months prior. Florida governor Claude Kirk addressed the crowd as featured speaker, pointing to several children from Little Princess Kindergarten and declaring that "it is for them we're doing this." Pictured above, board of regents' member Dr. Louis Murray breaks ground while, from left to right, board chairman Chester Ferguson, Governor Kirk, and President Millican look on. Two shovels would actually be used for the ground-breaking, though: the first, a decadent silver-plated item, was purely ceremonial and remains to this day in the University Archives (below). The second, an ordinary $3.50 shovel that Millican dubbed the Republican shovel, symbolic of state budget cuts, was used in the dirt.

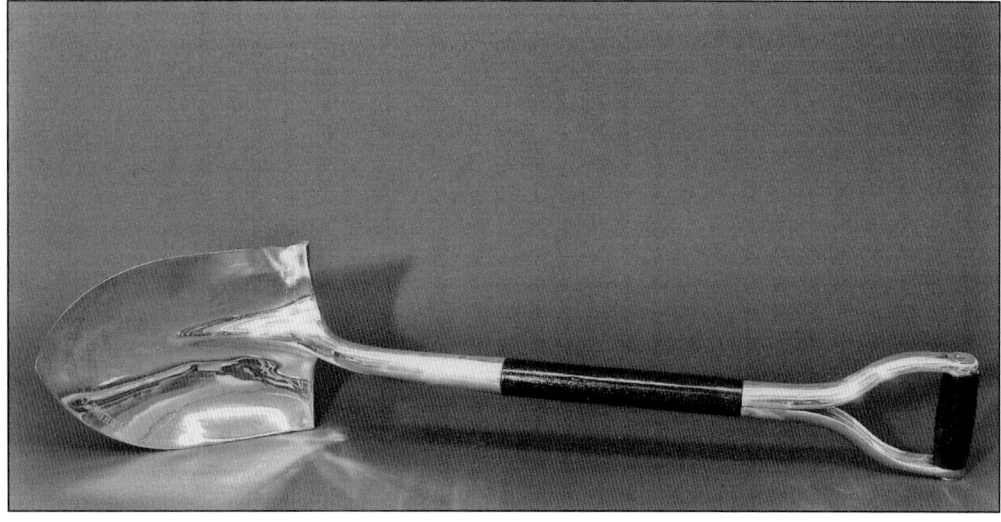

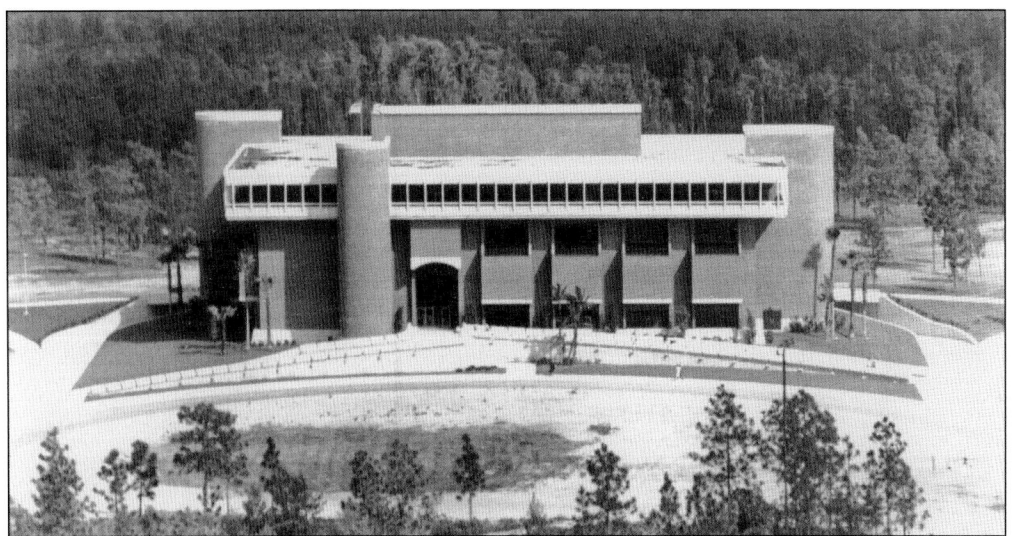

LIBRARY, 1967. After the groundbreaking ceremony, the land was cleared, utilities were laid, and roads were smoothed and paved. For two years, the site was crowded with dirt piles, concrete tubing, and construction vehicles, but soon, the sandy campus was transformed, and the first structure, the library, began to rise. Administrative offices moved from Church Street to campus on June 24, 1968.

ENGINEERING, 1966. Academically, good news came at a rapid pace after Millican's appointment. The board of regents approved a College of Engineering on September 16, 1966, joining the colleges of education, arts and sciences, business administration, and general education. Such was the rate of growth for high-technology in Florida that one study predicted a deficit of 20,000 engineering personnel by 1970, making this new College of Engineering essential to Central Florida's vitality. Fittingly, NASA awarded the university's first grant, $12,500, on April 18, 1968.

STUDENT APPLICATIONS AND COURSE CATALOG, 1967. By September 1967, Florida Tech had received more than 1,300 applications from prospective students (the first inquiry actually came on a postcard). Basic coursework, outlined in the *Accent on the Individual: Bulletin of Florida Technological University* at left, would include communications, humanities, physical education, sciences, and social sciences, though the catalog lacked specifics about the courses. In an early experimental curriculum decision, FTU also incorporated an environmental studies program through all four years of every student's coursework.

OFFICIAL SEAL, 1968. The university's official seal was unveiled on April 5, 1968, a black and gold Pegasus encircled by the school's name and founding date. The Pegasus harkened back to Greek mythology, the winged horse of the goddess Minerva, who imparted wisdom and skill to heroes. Nearly 20 Pegasus designs, 15 star variations, and 70 different color combinations were considered before the final seal was chosen. The hand-stitched banner at right was created by 'Toria Hubbard and gifted to the university in its early years.

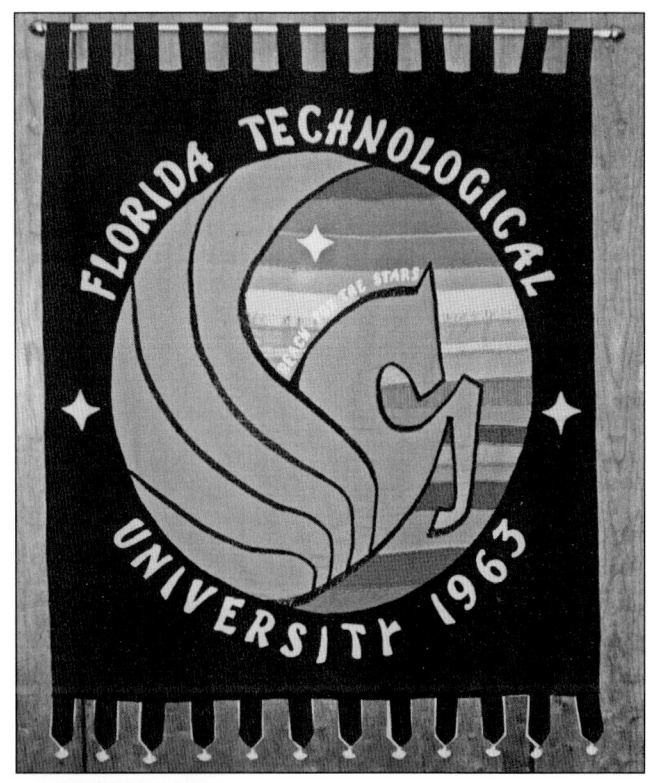

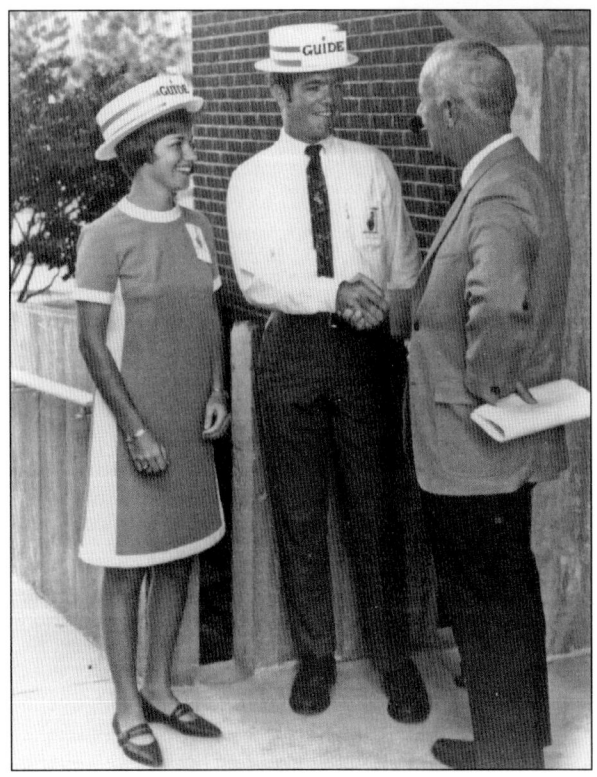

STUDENT GUIDES, 1968. Four hundred students and parents attended the first orientation at FTU, with Cathy Corton and Darryl Bannister among the original student guides.

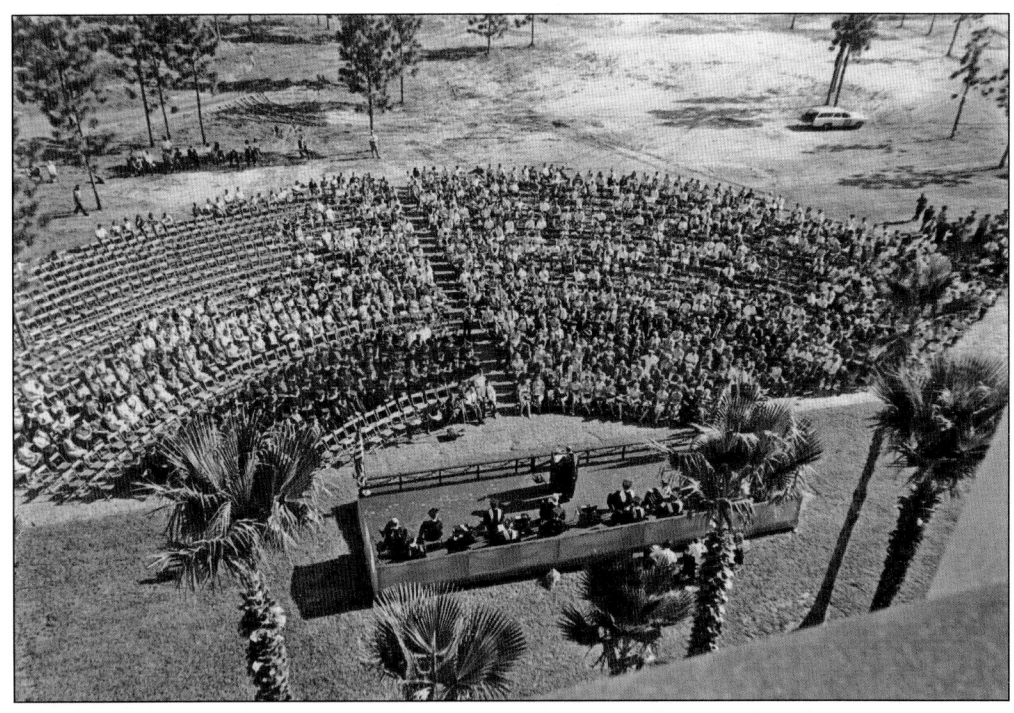

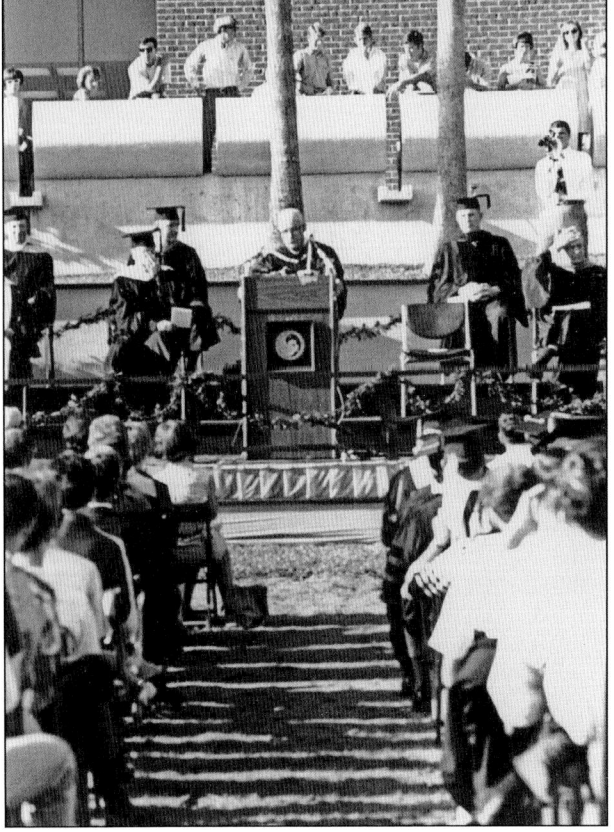

OPENING DAY CONVOCATION, 1968. Classes—originally scheduled to start in September—actually began on October 7, 1968, with 1,891 students enrolled, marking the culmination of five years of hard work for the entire Central Florida community. Tuition was set at $150 per quarter. And although the school was still pockmarked with dirt piles and sandy parking lots, it was not difficult for students to find their classrooms. After all, everyone shared the same building: the multipurpose library (where the opening day convocation was also held outside). Alumni remember a campus so new that grass was not yet planted and the mad hammering of construction frequently interrupted class, so wild that animals (notably skunks) wound up in the dorms, yet so friendly that professors actually helped students carry luggage to their rooms.

LIBRARY INTERIOR, 1968. Nearly all university business was conducted in the multipurpose library. Only the fourth floor was actually used as a library in the school's early years, with the third floor used for classes and the first two for administration and faculty.

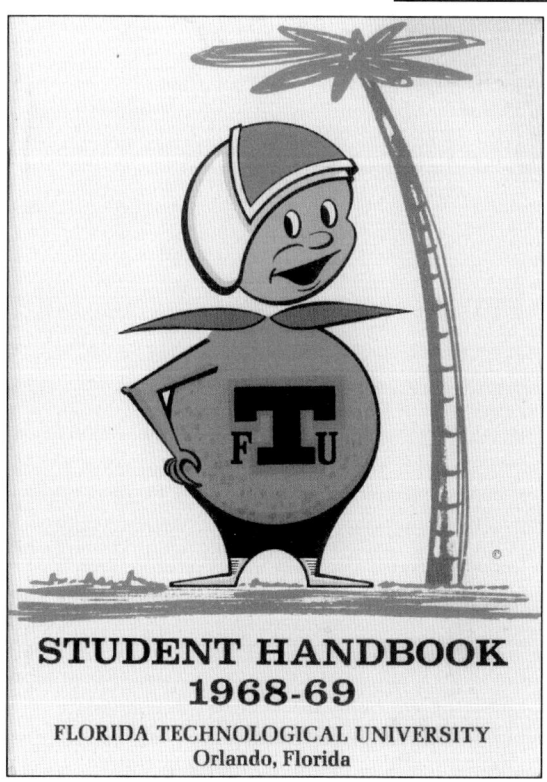

THE CITRONAUT, 1969. Student rules and academic policies were laid out in the first handbook. More importantly, though, the handbook unleashed the Citronaut (created by Norman Van Meter, who also designed the seal), a combination of an orange and an astronaut. The handbook suggested that all traditions were subject to change by the students themselves, so the students took this as a rallying cry . . . and the Citronaut was their first target.

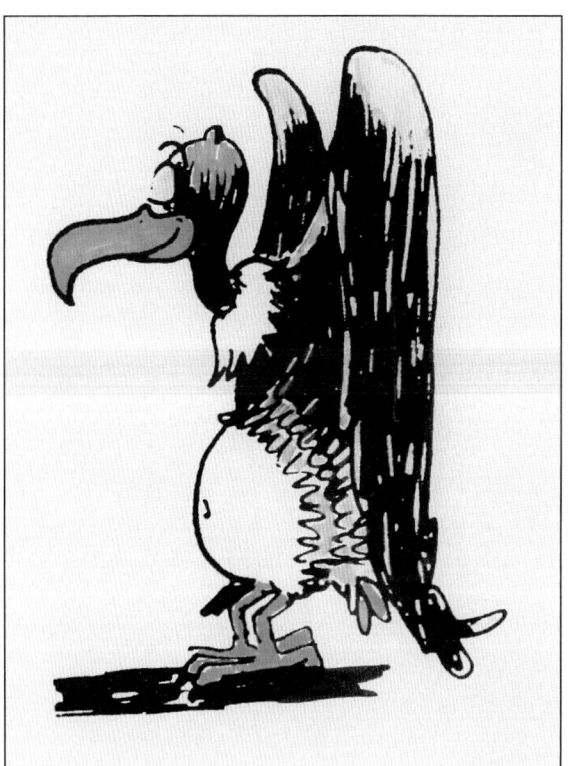

VINCENT THE VULTURE. The student newspaper, the *FuTUre*, compiled student suggestions to ensure the Citronaut would not become the mascot. One of these, from Health Center nurse Judy Hines, was Vincent the Vulture, a black and gold bird representing not the school's fascination with space, but instead the vultures circling the recently cleared construction sites of campus.

KNIGHTS OF THE PEGASUS, 1970. After a two-year period of compiling suggestions and a vociferous battle between Vulture and Citronaut supporters, student Charles Woodling's Knights of the Pegasus was voted as the school's official mascot, and unveiled during a December 4, 1970, basketball game against Patrick Air Force Base. Quickly the Knight found its way into all campus marketing materials, as shown here in an early student handbook. Sports teams began adding their own variation to the Knights: the basketball team was the Running Knights, football the Fighting Knights, and for a brief time in the 1990s and 2000s, teams were marketed as the Golden Knights.

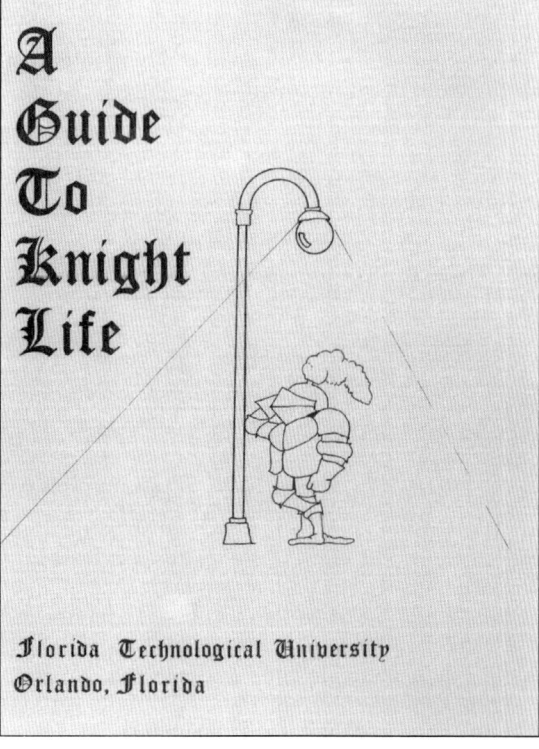

24

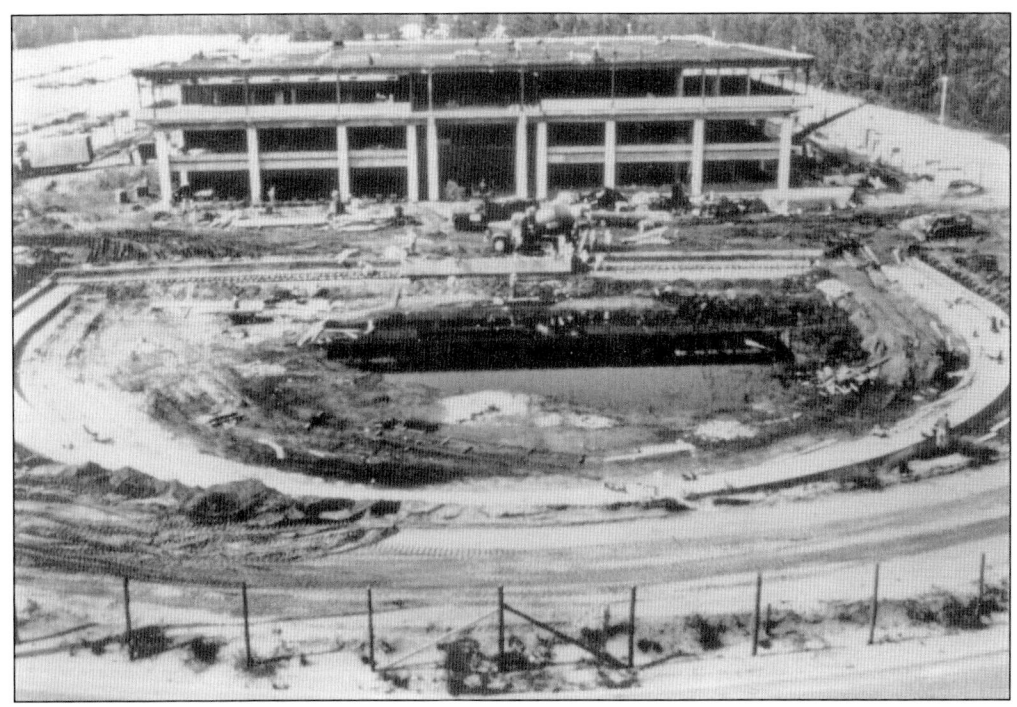

ADMINISTRATION BUILDING, 1970. Constructed in 1970, the Administration Building allowed staff members to migrate from the library to their new offices. Of note in these early photographs: an original campus thoroughfare traveled past administration all the way around the Reflecting Pond.

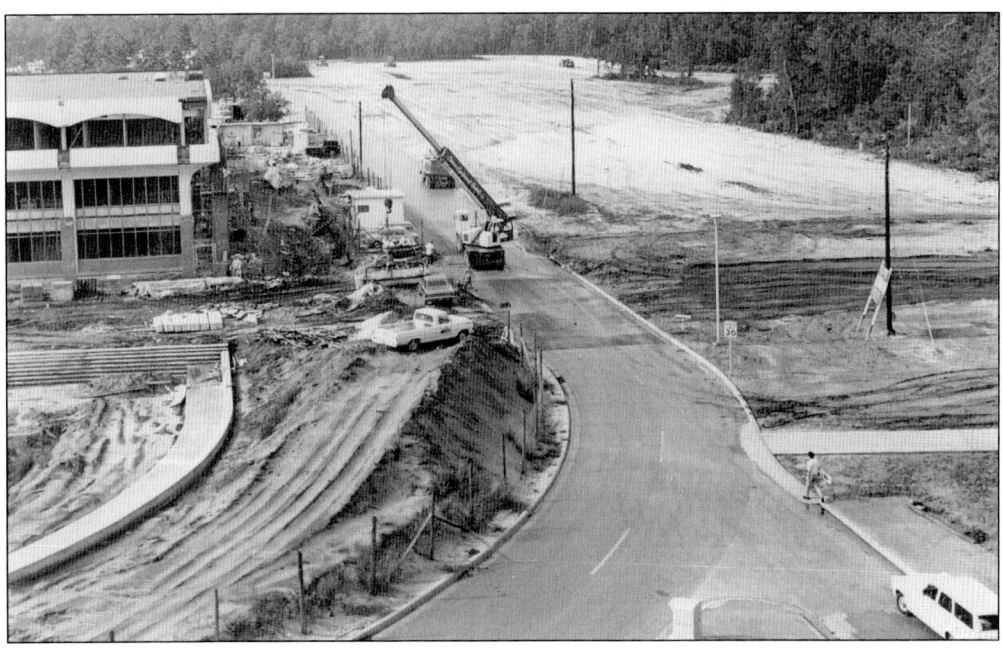

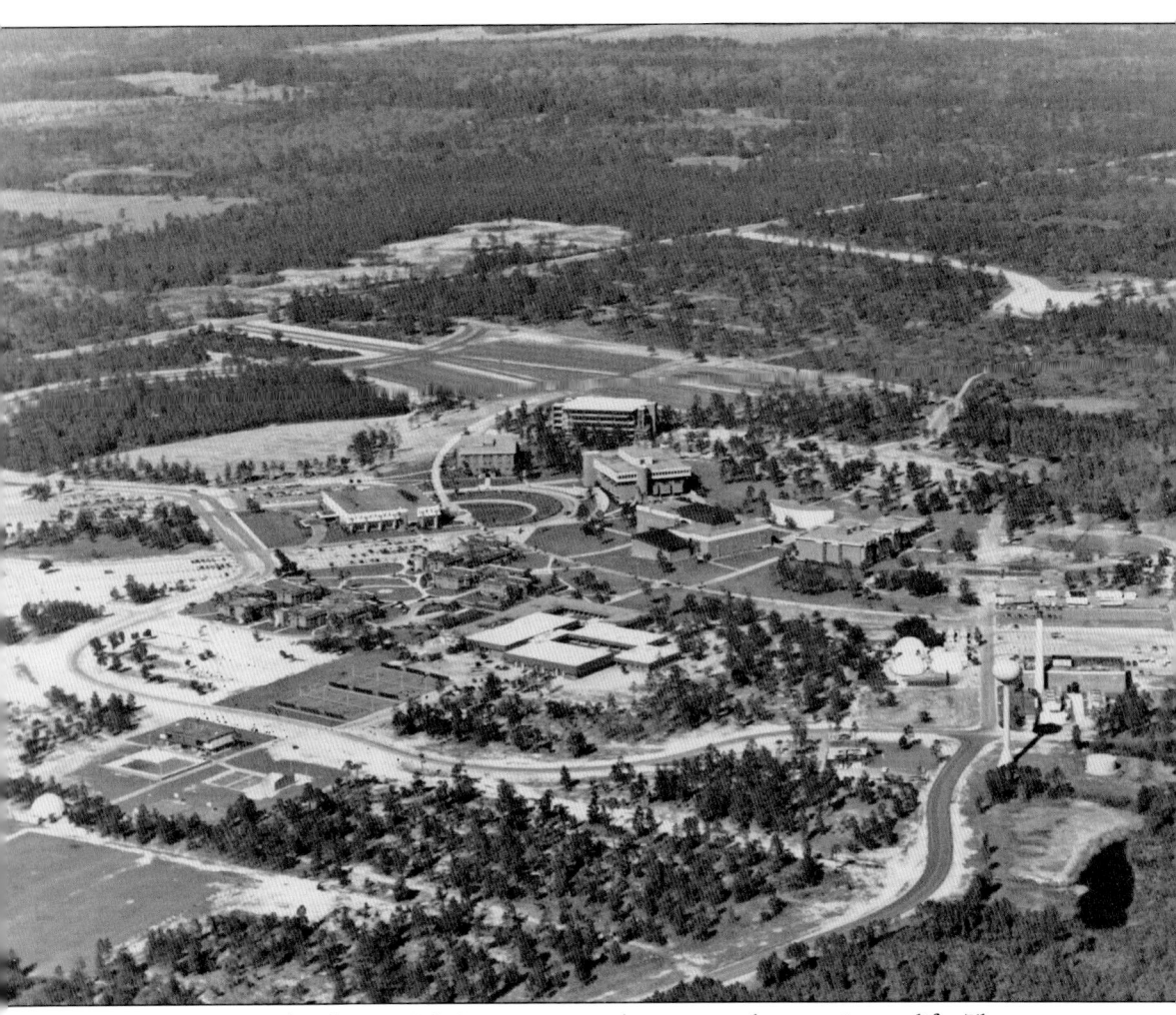

AERIAL VIEW. In this first aerial view, one sees the master plan coming to life. The campus water tower is finished, and the residence halls have taken shape. Also in the early master plan (and in this photograph) is a straight-shot line of physical structures, from south to north, the three earliest landmarks lined up as if they were feathers on an unwavering arrow through the circular target of the campus center: administration, the Reflecting Pond, and—farthest north—the UCF Library. Much like the fate of EPCOT, though, the master plan was a nice dream in the futuristic-minded early 1960s. Dampened by a decade of social upheaval, the ideas changed considerably. It would not be until the mid-1990s, when the Lake Claire Apartments were constructed on the campus's northern end, that the village concept was truly furthered. (Courtesy UCFAA.)

Two

Florida Technological University

Enrollment at Florida Technological University had by 1971 reached 6,500 students; in about the same time, faculty numbers had more than tripled, from just 80 initial faculty members to 320 in 1972. Facilities were coming to life across campus too, a series of brick structures surrounding the campus centerpiece of the Reflecting Pond. While some had been easy to approve and build, others (the Rehearsal Hall, notably) were only constructed due to the ingenuity of FTU administrators. In the early 1970s, on a brief layover while in Tallahassee, Dr. Leslie Ellis sought answers to why the school's requests for construction funds were being continually denied when clearly there were unused funds in its budget. After much heated argument about minor paperwork issues, Ellis secured $1 million to build the current Rehearsal Hall (money, it was rumored, that had been politically safeguarded for projects at the rival University of South Florida).

Because the school's first class in 1968 was composed of entirely freshman and juniors, the school's first graduation was held in 1970, cementing FTU's academic legitimacy. And by 1974, there seemed to be a palpable sense of satisfaction that Florida Technological University was a true college when an official alma mater was selected. Music student Elizabeth Eyles had proposed to President Millican the idea of a statewide contest to determine the university's song, and so FTU's chairman of music, Dr. Gary Wolf, organized a committee and for six weeks judged a wide range of entries (including one set to Beethoven's "Ode to Joy" and another to the Notre Dame fight song). The winning alma mater, written by Dr. Burt Szabo, was performed by the FTU concert choir and band during the 1974 spring commencement. This was another milestone for the young university: once degrees were conferred, they could not be unawarded, and once an alma mater was sung by the hundreds of graduating seniors gathered together at their commencement, it could not be unsung.

The idea of FTU had become reality.

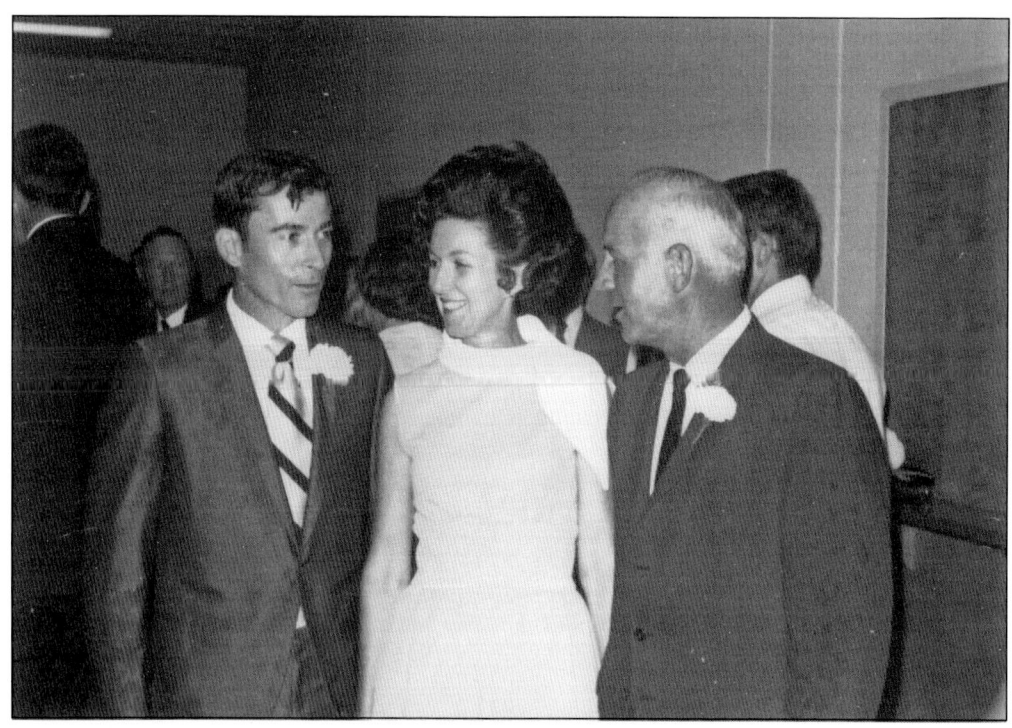

FIRST GRADUATION, 1970. Astronaut John Young, a Central Florida hero and veteran of three space missions, spoke at UCF's first commencement, held in the Orlando Municipal Auditorium (now the Bob Carr Performing Arts Center) on the rainy morning of June 14, 1970. He challenged listeners to use their education to "build better lives . . . and a better world." There were 423 FTU seniors who received diplomas at this first commencement ceremony, packing the auditorium with friends and family, a sign of the major logistical challenges to come at future graduations.

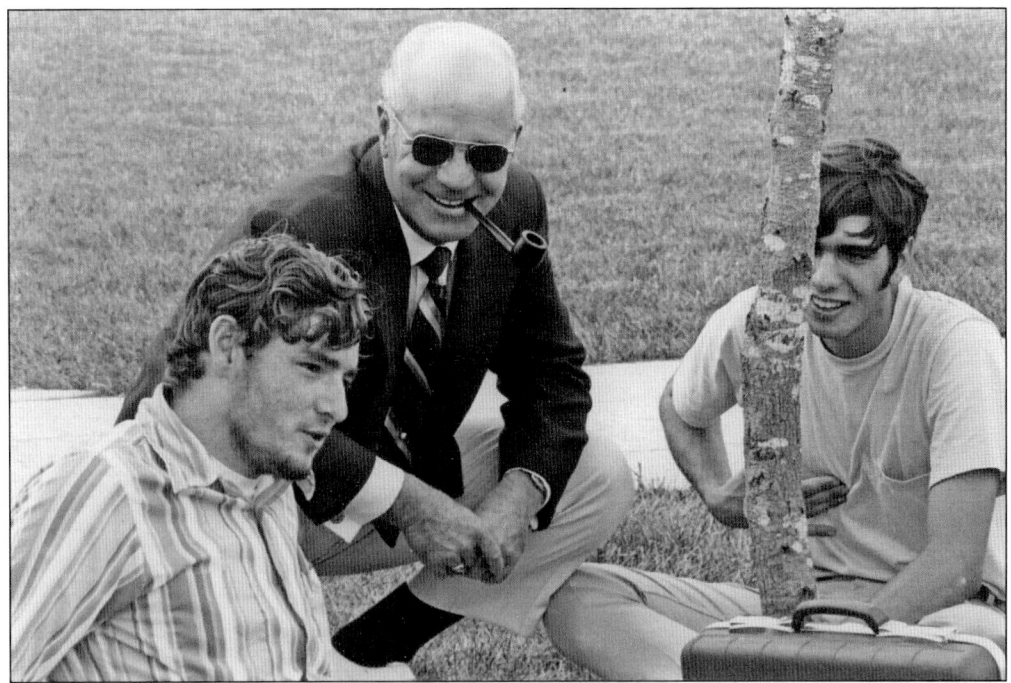

A Small School, 1970. Known for his trademark tobacco pipe and approachability, Dr. Millican imbued FTU with an intimate small-school feel, taking the time to meet and learn the names of many early students, exemplifying the university's philosophy, "Accent on the Individual."

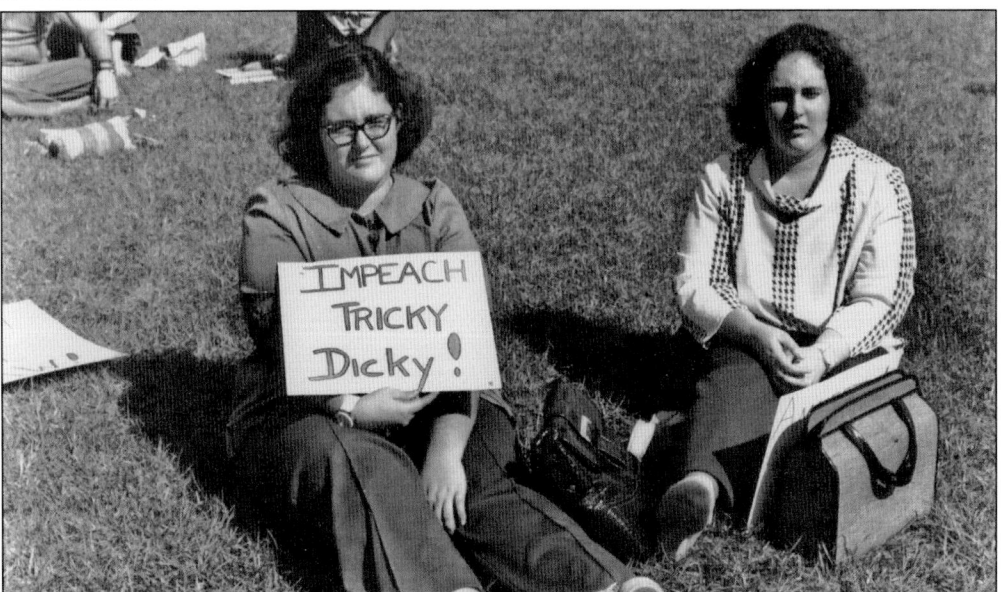

Campus Protests, 1970s. Though the 1970s were a time of political unrest across the United States, the fervor never engulfed Florida Technological University. While it is rumored that early buildings were constructed of brick to withstand student protests, or for use by the National Guard (tour guides still note that early windows are slit-like, perfect for snipers), student activism never reached a boiling point.

STUDENT GOVERNMENT, 1969. Student organizations started immediately after the beginning of classes. Walter Komanski, in whose name a tree outside of Ferrell Commons was dedicated, served as the first student body president in 1969. Years later, he became the university's first graduate to earn a position as a judge. Komanski's contributions to the university will likely never be matched: he presided over the first budgets (taking them from $5,000 to over $250,000), helped write the constitution, and helped select everything from class rings to the alma mater. Lee Constantine, student government's second president, seated below, would also go on to enjoy a lengthy political career. (Courtesy UCFAA.)

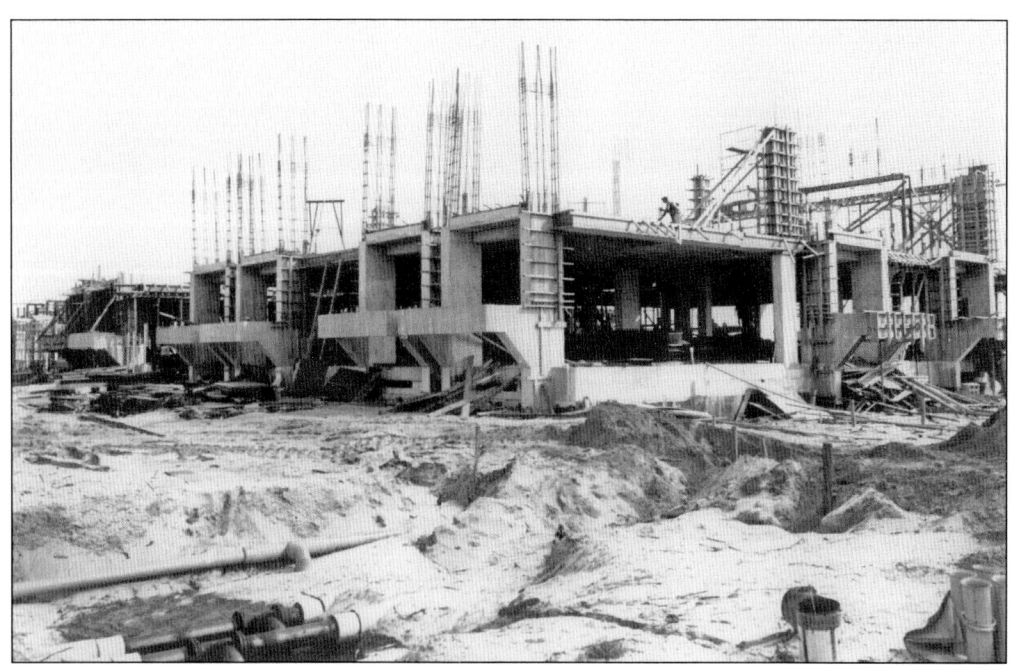

SCIENCE BUILDING (ABOVE), CHEMISTRY GARDEN (RIGHT). FTU's early buildings were mostly dedicated to the university's science aims, the Science Building (later renamed "Chemistry" for its intended purpose) rising from the dirt soon after classes started, its tall brick columns bordered by a concrete crown. Growth continued steadily for the next several years: in 1973, the Florida Board of Regents approved a master's degree program in computer science, the first at a Florida state university; radiologic sciences followed in 1974, with forensic sciences (at the time, one of few such programs nationwide) shortly thereafter. FTU had arrived and was flexing its academic muscles already.

F.T.U. ???

Vol. I Number I Orlando, Fla. Oct. 7, 1968

FLORIDA TECH OPENS

PROJECTED ENROLLMENT FIGURES EXPECTED TO BE MET

Dr. Charles N. Millican, FTU President, explains the story of the university seal during Sunday's open house. With the President are Martha Welty, Bruce Hamilton, Sharol Roberts and Shelby Prince.

FLORIDA TECHNOLOGICAL UNIVERSITY held its formal dedication ceremonies this morning, with the charter student enrollment expected easily to reach the projected first-year figure of 1,500.

Dedication of FTU, the state's newest university, was scheduled to take place at 9 a.m. behind the Library-Learning Resources building.

Chester Ferguson, chairman of the Florida State Board of Regents, was to make the major address. Orlando's Dr. Louis Murray, also a member of the Board of Regents, was to serve as master of ceremonies.

Ferguson, in remarks reported in more detail elsewhere, said in his prepared text the opening of FTU would have immeasurable impact on the lives of the people of the central Florida area "not only for this generation but for all generations to come."

Yesterday an open house was held at FTU from 2-5 p.m. President Charles N. Millican and his faculty and staff showed the public the first phase of the 1227-acre campus.

More than $10 million in buildings were completed in time for today's opening, and these represent only about one-fifth of the total plan for the school, which is expected to enroll 15,000 students within ten years.

The completed structures include the five-story Library-Learning Resources building which also houses the administration, faculty and a computer center; a three-story science building which has an adjoining auditorium seating 300; the village center; and the university's central utility plant. Two of the four residence halls are completed.

Plans call for the university to expand to a full four-year university next year with baccalaureate degrees offered in most areas.

"Strive For Excellence"

The following are excerpts taken from the prepared remarks to be delivered today by Chester Ferguson, chairman of the Florida State Board of Regents, at the dedication of FTU:

"The founding and growth of a university where there has been none before can be very moving. Men and women who have never known opportunity come to see the university as a symbol of hope. They see clearly that a new university represents the door they could never enter now opened to their children.

"For many of you in this audience, Florida Technological University represents the fulfillment of aspirations that a great center of learning be located in your midst. From this university will emerge trained and educated young men and women to lead this region and the state of Florida into new paths of progress in the years ahead.

"The activity which will be generated by the opening of this new university may be less dramatic than the launching of a space vehicle at Cape Kennedy, but its impact upon the lives of the people of this section will be immeasurable and its duration will be not only for the people of this generation but for all generations to come."

The charter student body, faculty and administration, as well as hundreds of area and state leaders, were expected to attend the dedication ceremonies.

The high-pressure salesmanship displayed by music professor Dr. Leon Sarakatsannis during registration last week led one competing professor to comment: "Beware of Greeks bearing gifts."

Transit Schedule

The Orlando Transit Company will be providing bus service to the campus.

Buses will depart from the terminal at Central and Pine streets, in downtown Orlando.

The first bus will leave at 7:15 a.m., followed by another at 11:15 a.m. and one at 4:15 p.m.

Service from campus begins at 7:50 a.m. Two more buses will leave at 11:55 a.m. and 4:55 p.m.

Fare one-way will be 35c.

F.T.U.??? The first campus newspaper was started by two high school students, Linda Tomlinson and John Gholston, accepted for FTU's first classes but not yet enrolled. With President Millican's support, they worked throughout the summer to publish the first edition in time for the start of classes in October 1968.

WE LIVE IN THE PRESENT, BY THE PAST, BUT FOR THE....

FuTUre

Vol. 1, No. 6 Florida Technological University Orlando, Fla. Nov. 15, 1968

Golf Group Meeting

Twelve members of the newly formed FTU Golf Club participated in the club's first meeting Monday, Nov. 11, at the Rocket City Country Club.

Under the leadership of faculty advisor, Mr. Richard Hunter, the club golfed despite the tornado warning that afternoon. Wayne Leland led the first outing by posting a 9 hole score of 44.

A second meeting is scheduled for Monday, Nov. 18 at 4:00 p.m. at the Rocket City Country Club. All interested students and faculty members are invited to attend. A $1.00 playing fee is required and clubs are available from Mr. Hunter in room 353 LR.

Band To Play

Village Center Student Activities has arranged for the 80th Army Post Band to present a Concert at Florida Technological University from 2:00 - 3:45 p.m. on Friday, November 22, 1968. The group of approximately 35 musicians under Band Master John Murah will perform a varied program of concert band music, show music and rock 'n' roll numbers in the Multipurpose room of the Village Center.

The 80th Army Post Band is from Hunter Army Air Field in Savannah, Georgia, and is making other appearances in the Central Florida area, including a performance at Stetson during the same week.

All FTU students, faculty and staff are encouraged to attend this performance.

FTU ?? IS NO MORE

PRESS TOURS FTU

Members of the press from the U.S. and Europe toured FTU Thursday afternoon courtesy of the Florida Development Commission. The FTU stop was part of a state-wide five-day junket designed to promote Florida.

Arriving on campus at 3:00 p.m. Thursday the seventy newspapermen and women were greeted by Vice-president of Student Affairs, Dr. Rex Brown. The press then toured the Library-Library Resources Building. They were given FTU literature concerning university programs and development.

The tour started Monday, Nov. 11, in Pensacola. On Tuesday the group was in Tallahassee where they met with Governor Kirk and other Florida officials. From there the Wednesday tour of the Tampa area, the press went to Cypress Gardens on Thursday and then came to Orlando and FTU. Today they will be visiting the Miami area.

John Slinkman of the "Navy Times" said the journalists represented such publications as the U.S. News and World Report, "Good Housekeeping," the "Boston Herald-Tribune", the "Cincinnati Magazine", "Florida Life", and the "National Geographic".

The European journalists came from Norway, Germany, Sweden, and Italy. A reporter for the European news agency Reuters was also present for the tour.

MILLICAN AIDS PANTHERS

Dr. Charles Millican, president of FTU, kicked-off at the Panther - Norfolk game Sunday, Nov. 10, at the Tangerine Bowl.

In preparation for the event, President Millican practiced last week on the FTU campus as well as at the Tangerine Bowl.

President Millican did not let the FTU students down. He delivered a beautifully arched 30 yard kick-off, starting the game with a spirit of enthusiasm.

The day of the Panther game was officially "FTU day." Tickets for faculty and students were offered at a reduced rate.

The FTU ??? is no more!! After many long days of deliberation FTU has taken a step towards the future.

H. Gorden Robbins, Orlando Insurance man, submitted the name after it appeared in Jean Yothers "On The Town."

Robbins attended Rollins College and studied commercial art. He was also the Business Manager of the "Sandspur", the Rollins newspaper, and a member of Alpha Delta Sigma, an honorary advertising fraternity.

He was elected President of Florida Inter-Collegiate Press Association in 1930.

Robbins also attended Boston University and Syracuse.

Robbins and his family came to Orlando in September of 1946. His position here was that of manager of the Jacksonville branch of the John Hancock Insurance Company.

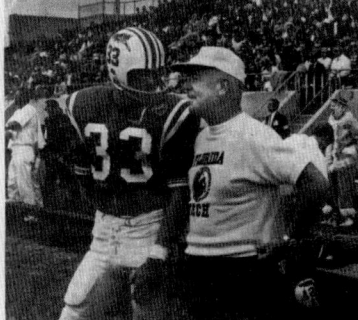

Dr. Millican receives kickoff advice from Orlando Panther Bill Johnson.

The *FuTUre*. In the newspaper's early years, the staff worked with scissors and glue to assemble each issue, the first several of which bore the title *FTU???* until a campus-wide contest found a replacement name, the *FuTUre*.

CLASSROOMS. The school's first classroom building (now Howard Phillips Hall, pictured), along with the new Humanities and Fine Arts Building (now Colbourn Hall), continued the university's early aesthetic. Surrounded by sweeping greens and large trees, the brick-faced HFA Building extended the campus to the north and also continued a tradition of multipurpose facilities for a growing school still short on space. In fact, the Humanities and Fine Arts Building was initially constructed as an early-1970s architectural experiment for state universities, "The First Florida University Building System," which focused on long-term adaptability.

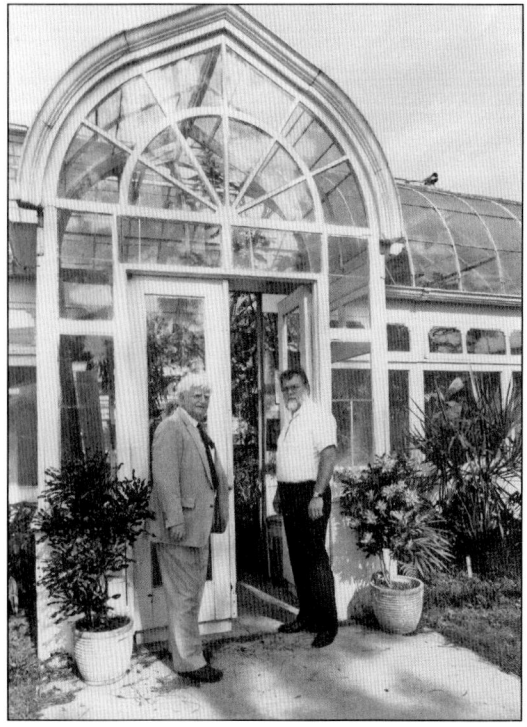

THE STOCKARD GREENHOUSE. Some campus structures were not constructed from scratch, but were rather donated to the university and moved to campus. Donated by Mrs. A. E. Stockard of Winter Park, the FTU Greenhouse (and all of its many pieces and plants) was disassembled, transported, and reassembled on campus, all by volunteers. The process took over five years and involved not simply the project's coordinator, Dr. Henry O. Whittier (pictured left), but also the campus Biology Club and the Beta Beta Beta Honor Society.

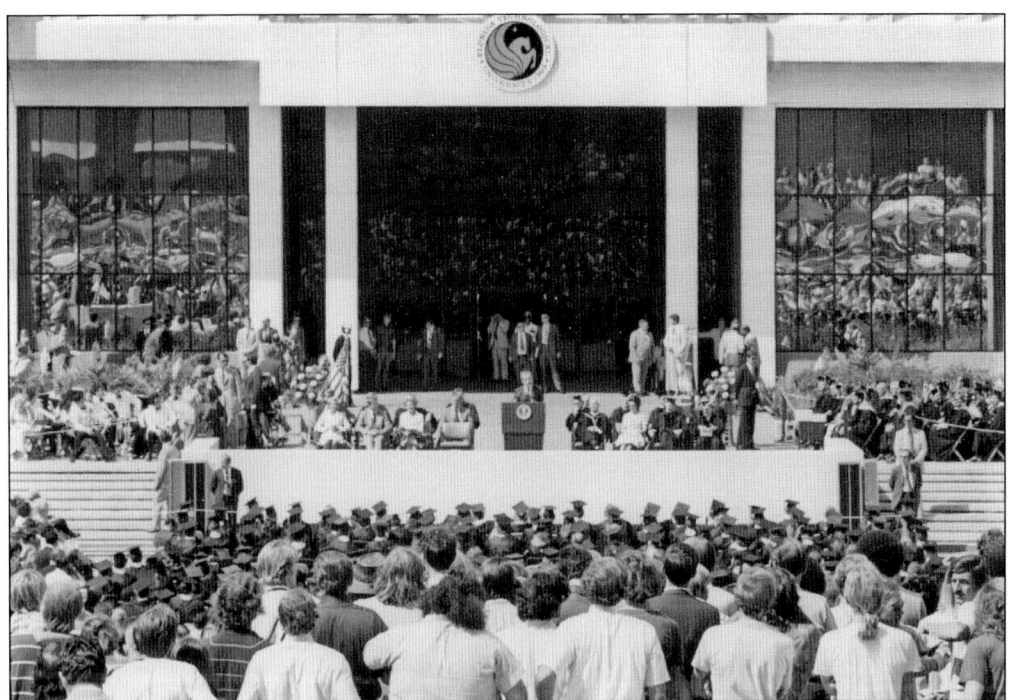

PRESIDENT NIXON, 1973. Without notice, on the morning of June 5, 1973, Dr. Millican received a phone call from the White House stating that Pres. Richard Nixon would like to speak at FTU's upcoming commencement ceremonies. The school had just three feverish days to plan, but would handle its first moment in the national spotlight well: the Reflecting Pond was drained for the graduation, Nixon's helicopter landed in the grass outside the Administration Building, and Secret Service personnel reportedly staked out on rooftops. Nearly 10,000 people gathered on campus on June 8 to hear President Nixon speak, at that point likely the school's largest crowd ever.

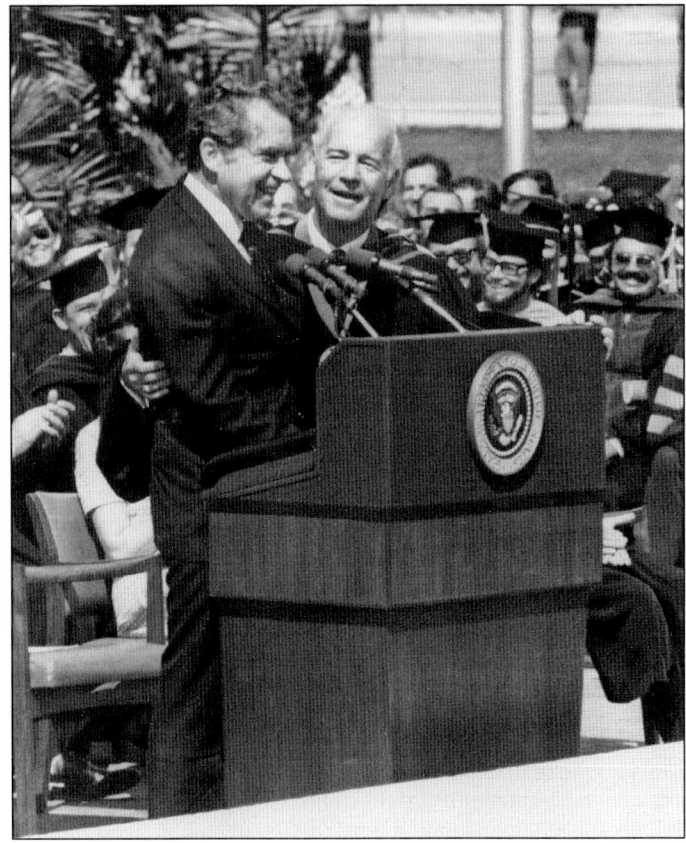

MUNICH OLYMPICS, 1972. Students and faculty in FTU's early years faced an uphill battle in building a reputation for the school's art programs. Prof. Steve Lotz (pictured at left with alumnus Robert Magnusson and Johann Eyefells), who was among the first art professors hired, helped FTU gain international notice in the arts when his floating sculptures, a commentary on Czechoslovakia's deteriorating village life, were displayed at the Munich Olympics in 1972.

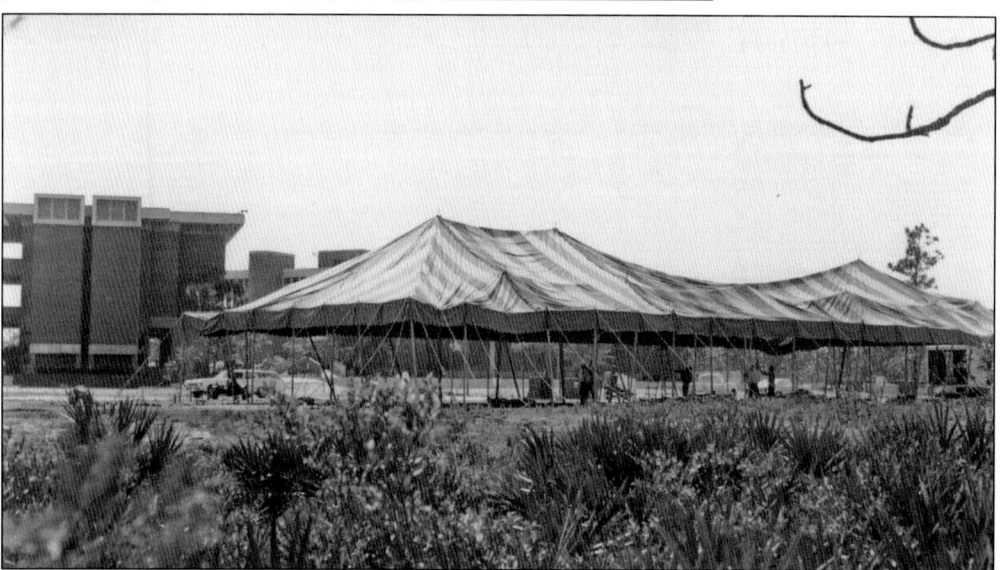

THEATER TENT, 1969. Theater students at FTU practiced and performed in a tent, acceptable when the weather was mild, but unbearable when the weather turned. The first production, on an icy 35-degree night in December 1969, was Shakespeare's *Titus Andronicus*, requiring all actors to wear togas, while 150 audience members shivered under blankets. Throughout its two-year history at FTU the tent occasionally collapsed, and students avoided a 3-foot indigo snake living under the stage. In spring 1972, when a new science auditorium was completed, the actors moved indoors.

FLORIDA REVIEW, 1972. In 1972, Florida Technological University launched its first literary magazine, the *Florida Review*. Seven students worked with founding editor-in-chief Doug Frazeur to publish this first 50-page issue, and with the help of student funding, the initial print run totaled 5,000 copies. Interestingly, the magazine's first fiction editor, John Browne, was a microbiology major, a sign of the unique relationship between science and humanities majors and of the growing popularity of disciplines outside of technology.

EDUCATION BUILDING, 1977. While science programs received a great deal of attention, FTU actually received more applicants for education than engineering. And with the opening of the Education Building, which was now the most striking structure on campus (winning the first Governor's Design Award), many began to wonder, why was the school even called Florida Tech?

37

The Late 1970s. As new buildings were finished and new programs started, there was a sense of great things to come. Perhaps FTU would rival the California Institute of Technology and the Massachusetts Institute of Technology someday, becoming the southernmost point of a golden triangle of higher education, as Florida governor Claude Kirk had predicted at the ground-breaking. But there was indeed a conflict from the start: though this was supposed to be a broad-based state university, administrators still had to convince outsiders that this was not solely a technical school. Early students might not have known, but the university was experiencing its first growing pains: no amount of master planning could dictate exactly what the school would become, and the late 1970s would see sweeping changes for FTU.

Three

THE VILLAGE CENTER
THE FIRST TWO DECADES OF STUDENT LIFE

Alumni from the school's first two decades recall a rural campus dense with forest, a quiet area with only a Piggly Wiggly and a few local hangouts: Knight-Out Pub, Pizza Hut, and Point After. There was such solitude in the school's first decades that the entire Lambda Chi Alpha fraternity could use campus forests for gigantic capture the flag tournaments, searching through the dark pines and palmettos without ever seeing car headlights cutting into parking lots, without even seeing another soul all night. Early football players recall fulfilling late-night dares to walk from the university to bars 3 miles away, eyes closed, using the empty two-lane University Boulevard. This might have been Orlando, but it was not yet a bustling metropolis.

On campus, students congregated at a series of one-story buildings in the heart of the Apollo residence halls called the Village Center. In addition to student resource offices, the Village Center featured an auditorium, art galleries, pool halls, and a health center. According to the original master plan, this was supposed to be just one of many village centers across campus, but this vision was never realized.

As the university expanded, the Village Center was outgrown, and academic services and student life offices were scattered far apart, frustrating students who wanted one central student union. After all, each of Florida's other eight state universities had such a structure.

In 1979, the school's first student union was approved. Constructed behind the library, it would incorporate the campus bookstore, lounges, and snack bars. But because it was just an ancillary unit to the faraway Village Center, rather than a single structure bringing together all of student life, students refused to see it as their student union. So by the time this building opened in February 1981, the sign at the entrance to its long breezeway read, "Student Services" (now "John T. Washington Center"), keeping alive the promise of a student union. Administrators took a final low-risk stab at a student union in the 1980s, constructing a restaurant-pub called the Wild Pizza just outside the Village Center. For the next decade, this building became a hot spot, anchoring campus life . . . until the 1997 completion of a true student union changed the entire campus dynamic.

VILLAGE CENTER, 1978. The Village Center, pictured above under construction, was the first focal point for student life, housing not just offices and campus resources, but also hosting movie screenings, guest speakers, and orientations. The first registrations had taken place within the library, but as early as 1970, students even registered for courses in the Village Center, standing in theme park–length lines over a four-day period, their fee information recorded on magnetic tape. Though FTU developed its first computerized registration system in 1975, the General Registration and Sectioning System (GRASS), the add/drop period for courses still occurred in a face-to-face setting in the Village Center throughout the 1980s and 1990s, with entertainment for the excruciatingly long waits, pictured below.

MEAL HALL, 1969. The Village Center also housed the school's first dining hall, which is still used today.

DOMES, 1974. Kappa Sigma brothers Mike Clawson (left) and Manuel "Manny" Rodriguez (right) stand in front of a geodesic dome near the campus Physical Plant. Long since demolished, the cramped domes actually housed the university's first gym. After graduation, Rodriguez fulfilled a long career with the Alumni Association as director of alumni relations, overseeing the development of the FAIRWINDS Alumni Center, where after his passing in 2005, the second floor office suite was named in his honor. (Courtesy Lloyd Woosley.)

PEGASUS FLYING CLUB, 1972. Some of Florida Technological University's first clubs were formed with academics in mind, with many influenced by the university's early emphasis on science and technology. The Physics Club formed in 1972, and the Pegasus Flying Club was an early campus organization composed of both students and faculty dedicated to recreational flight.

EGG DROP, 1985. For many years, engineering students have competed in egg drops at the annual Engineer's Fair. Students drop raw eggs, encased in protective coverings of their own designs, from the top of the Engineering Building.

MINI-BAJA. Long a staple of student culture in the College of Engineering, FTU and its Society of Automotive Engineers hosted (and won) the first-ever mini-baja competition in 1977 (pictured above) and again in the late 1980s (pictured at right). The event features various endurance tests, including a Bog Run that pits the student-designed mini-baja cars in tough, muddy spots.

MARCH OF DIMES, 1971. Service events have been a part of the campus culture since the first years of classes. One of the first major philanthropic events on campus was the 1971 March of Dimes (left). Kappa Sigma's Seesaw Marathon, organized by future Sen. Lee Constantine, also made headlines, and campus Greek Week competitions (below) have frequently been tied to service organizations.

YEARBOOKS. Though yearbooks have since disappeared from campus, the 1970s and 1980s saw annual attempts to document student life. (Right, courtesy Orientation Office.)

BONFIRE, 1970s. Before the introduction of the football team in 1979, homecoming coincided with spring basketball. Florida Tech's first on-campus homecoming game was held in 1978, when the basketball team took on Biscayne College in the new Education Gym. Old events from the 1970s included a formal homecoming dance, an Alumni Beer and Barbecue (held in the Village Center multipurpose room), and—in a tradition that continues today—a homecoming week comedian. Between 1977 and 1992, the homecoming bonfire was even lit on campus.

Rita Reuter, 1977. Perhaps the most memorable homecoming event of FTU's history was the selection of master's student Rita Reuter as homecoming queen 1977. Typical of many of the nontraditional students of those days, Rita was 58 years old, working as a student assistant at the FTU Library. Soon after her nomination, she achieved campus celebrity status (complete with a group of supporters known as Rita's Rooters), then local celebrity status, when *Orlando Sentinel Star* education writer Jeff Kunerth gave Rita a write-up. The Associated Press made the story national, and soon thereafter, Barbara Walters discussed Rita's accomplishment on ABC, and David Brinkley lobbied for her on NBC. Sea World even held a Rita Reuter Day. Her crowning achievement was an appearance on the *Tonight Show* with Johnny Carson, placing Florida Tech in the nation's living rooms for the first time.

HOMECOMING KING, 1978. The next year, 1978, FTU began its tradition of crowning a homecoming king to go with the queen. The first homecoming king for the university was Robert Baker, a member of the Social Work Club.

ORIENTATION, 1978. The first of its kind in the state of Florida, the Orientation Team (O-Team) officially began in 1973 as a program to introduce incoming students to the university, though previously the school had utilized a handful of student guides. O-Teamers would guide freshmen on tours, facilitate discussions about campus life, and plan social activities. (Courtesy Orientation Office.)

JIMMIE FERRELL, 1978. The legendary creator of the O-Team, Jimmie Ferrell, had a tremendous impact on student leaders throughout the 1970s and 1980s. Following his passing, the Village Center was renamed Ferrell Commons. Ferrell also became known for his sometimes-wild team training exercises, right, a tradition that continues today with the O-Team's annual spring retreats. (Courtesy Orientation Office.)

O-Team Jerseys. Fraternities and sororities at the university have always been tied strongly to campus leadership organizations, from student government to O-Team. Several members of Lambda Chi Alpha fraternity, in fact (pictured here in a 1980s Rush brochure), began the O-Team's long-standing tradition of wearing personalized sports jerseys during orientation sessions, when in the mid-1980s they asked head football coach Gene McDowell for a set of jerseys to help promote the football team. (Courtesy Roy Reid.)

Men of UCF. Some campus traditions, however, such as the mid-1980s *Men of UCF* calendar, did not stick.

50

WORLD RECORDS. Students at UCF have several times attempted new world records. Early students tried to set a record for most people in a VW bug (above); in the mid-1980s, students gathered to set a record for most people on a waterbed (below).

51

John T. Washington Center. Unofficially called "the Breezeway" by students, the complex housing the campus bookstore is actually named after John T. Washington, a sociology professor at UCF who helped establish the Black Student Union. Prior to its opening, the campus bookstore was located on the bottom floor of the library, seen below.

Four

UCF
THE TRANSITION YEARS

State budget cuts, an obstacle to FTU's master plan since the 1963 founding, became more frequent throughout the 1970s. And despite President Millican's steady leadership, the nation's economic crises were hitting FTU hard. In 1974, in fact, an energy task force was created, with campus community members working on plans to curb the growing university's energy usage (proposing not just obvious ideas, such as carpools, but also four-day workweeks). Ultimately, to conserve energy, the school shut down for 10 days in December 1974, even silencing the Reflecting Pond's fountain. And in 1976, due to massive budget cuts for the state university system, FTU closed through the winter break again, from December 19 to January 4. Dr. Millican, in the university's newsletter, stated in no uncertain terms what these funding deficiencies meant for the school: "Pure and simple, FTU does not have the money needed to operate in accordance with its charter as a general purpose university, capable of offering a wide variety of courses—night and day—to Central Florida residents." His words, stripped of guarded PR-speak, showcased the gravity of the problem. Many now wondered if FTU could ever achieve the promise that the entire community had imagined during the groundbreaking ceremonies. With so little money, was it even possible?

After all, since the school's founding as the space university, man had reached the moon, and now the nation was living the dark aftermath of Vietnam, Kent State, Watergate, and the soul-crushing assassinations of the 1960s. Yes, Walt Disney World had opened across town, but the soaring promise of Florida Technological University seemed suddenly grounded.

The 1980s, under the leadership of Pres. H. Trevor Colbourn, now proved vital to the school's future. While alumni from the 1980s reflect upon these years as an era of incredible excitement amongst the student body, an era when the school still felt untouched by Orlando's increasing development, the students and faculty of the 1980s, in laying the groundwork for the future of the school, fulfilled an extremely difficult task.

TIME CAPSULE, 1976. Certainly, there were highlights of spirit in the late 1970s despite a bleak national forecast. In front of the Administration Building on December 1, 1976, FTU held a ceremony to bury a time capsule collecting memorabilia from the university's first 13 years. This ceremony showcased the optimistic feeling that, despite all difficulties, the school was permanent, and future generations would someday enjoy that small piece of buried history. But, though no one knew it at the time, the time capsule also marked the end of an era, for Florida Technological University's remaining time was limited. (Courtesy UCFAA.)

MILLICAN RESIGNS, 1977. Just months later, on April 14, 1977, President Millican announced that he would resign by the next January so that someone new could assume leadership and guide the school through its next phase of development. But what would that next phase look like? Identity at FTU was far from solidified; a time capsule alone could not seal the permanence of the school's image.

54

FTU AT DECADE'S END. Ever since the founding, tension had been mounting over the school's name. This was an institution of diverse educational offerings, and the name Florida Tech caused communications personnel to constantly explain away misconceptions. By decade's end, a name change for Florida Technological University felt inevitable. FTU had been a dream born of the space age, but technology no longer entranced the nation in the same way, and it certainly did not define this university.

DR. LESLIE ELLIS. Dr. Leslie L. Ellis, dean of Graduate Studies and Research, served as the interim president in the brief span after Millican's resignation. He also led the six-month search to find a replacement, and in 1981, he was named the university's first provost.

PRESIDENT COLBOURN, 1978. H. Trevor Colbourn, the university's second president, came to FTU from San Diego State University, where he had served as acting president. Prior to that, the Australian-born Colbourn had established himself as a Revolutionary War–era scholar, teaching at Pennsylvania State University, Indiana University, and the University of New Hampshire. Colbourn had actually suggested a name change during his December 1977 interview with the board of regents, declaring Florida Technological University a misnomer for the school's mission. When he made his opinions public in a meeting with local media, the board of regents quickly fielded a pro and con session, then voted unanimously for a new name at their December 1978 meeting. In just two days, the state legislature approved their decision, the governor signed off, and the new name became official on December 6, 1978 (a month before Trevor Colbourn's January 15, 1979 inauguration). A new seal would be installed over the Administration Building on March 7, 1979.

ADDRESS CHANGE, 1979. A new name meant many changes, with new signs and logos across campus and even a new address of 4000 Central Florida Boulevard, though one can still find traces of the old university today (including books in the library with Florida Technological University stamped on their pages). Even the alma mater underwent revision, as the letters *FTU* were pivotal to rhyme and meter. The school also advertised new diplomas to FTU graduates, complete with a disclaimer: "Florida Technological University from fall 1968 through fall 1978; University of Central Florida from fall 1978."

COLBOURN'S NEW VISION, 1979. In his inaugural address, President Colbourn offered words still resonant today: "It is not enough to talk of our undoubted potential: the time has come for boldness, for imagination if that potential is to be realized. Our future—the future of Central Florida, of this university—is what we care to make it." Visibility would become a top goal throughout the 1980s, with President Colbourn initiating a football program in 1979 and knighting the school's first mascot at the 1980 home opener below.

58

GRADUATION, 1985. Though funding remained strained, growth continued steadily throughout the 1970s. Classes began in 1968 with 1,948 students, and even with tighter admission standards, fall quarter 1977 enrollment hit 10,922. By the end of the 1970s, UCF had awarded its 15,000th degree. By fall 1982, enrollment exceeded 14,000 students, and by 1983, the school was holding consecutive graduation ceremonies in a single day to accommodate the large crowds, utilizing different commencement speakers for each ceremony. In fall 1983, UCF even opened its Lifelong Learning Center in partnership with Brevard Community College, expanding the university's influence to the East Coast, pictured below. Though this succession of milestones felt encouraging for the University of Central Florida's future, the population growth soon caused difficulties in traffic patterns, in parking, in classroom space, and in campus resources, problems that would be bearable throughout the 1980s, but crippling by the early 1990s.

PROMISES FULFILLED. The rising enrollment numbers in President Colbourn's first five years necessitated more facilities. The second wave of sorely needed campus dormitories, the Libra Community, came in 1981 with the simultaneous construction of three similar structures, doubling student housing. Several student service buildings (including the brand-new Health Center, above, replacing a tiny facility in the Village Center) saw completion throughout the decade too, all continuing the early brick design, seeming less like a bold new vision for a new university than the fulfillment of Florida Tech's master plan. Perhaps the most important project, however, was the 1982 library expansion seen below, an upgrade that finally allowed the school's first academic building to be renovated for its intended use simply as a library. A four-story trapezoidal addition was built onto the library's back, doubling the floor space; the interior was gutted, the main entrance was rebuilt, and the busy road that ran around the library was chopped up and turned into a sidewalk.

COMPUTER CENTER II, 1982. Great technological changes were in store for the university throughout the 1980s. In 1982, a second computer center was built (though it would still be years before it housed any computers truly accessible for students). And in June 1981, the UCF Library installed the new technology of microfiche, replacing old card catalog cabinets on the second floor, saving untold space and making research and restocking more efficient. In 1981, also, the university installed its own telephone system, thereby sparing its reliance on outside telephone companies, one more step to becoming a mini-city within the Greater Orlando metropolitan area.

COMPUTER SCIENCE. At the same time as the university's name was changing, the board of regents was also authorizing the school's first resident doctoral program: computer science (making UCF the first Florida university to offer a computer science doctorate). And UCF computer science students soon made their professors proud: the Computer Team would win regional programming contests with regularity, several times placing in international contests, pictured below. In December 1981, engineering also received its doctoral programs, capping more than a decade of growth for the College of Engineering's undergraduate enrollment.

UNIVERSITY BOULEVARD. At the university's opening, FTU had 1,250 paved parking spaces, acceptable for the first class of 1,500 students in 1968, but within just five years, there were now 8,400 student, faculty, and staff vehicles, and no new spots. As early as 1972, news clippings described student petition efforts for new lots; others showed students creating parking spots wherever they could, from sandy fields to forest clearings. But just as important, many of the area's roads were initially unready for UCF's growth (University Boulevard, leading directly into campus, was just two lanes). News articles described standstill morning traffic lines on University Boulevard extending 3 miles.

CAMPUS VISITORS. The late 1970s and early 1980s saw a number of important guests to the university. Julian Bond spoke in 1971, and Sen. Joe Biden (above), still 30 years from rising to the nation's vice presidency, gave an address in 1978. Sen. Bob Graham and Tennessee Williams both spoke at the university in 1981, and William F. Buckley Jr. and Henry Kissinger (below) each spoke at President's Circle Dinners in the early 1980s.

CEBA, 1989. Perhaps the boldest project of the 1980s was the College of Engineering and Business Administration complex, built in two separate phases over five years, and completed for fall 1989. The CEBA complex provided facilities for both colleges, including the school's first teaching restaurant (the precursor to the Rosen College of Hospitality Management). Prior to the construction of the CEBA complex, engineering had been housed in what is now the Math and Physics Building, and Business Administration had taken up half of Howard Phillips Hall. The university's business programs had been growing explosively, though, with the student population nearly doubling from 1979 to 1989 (from 2,600 to 4,586). The initial enrollment for business programs in 1968 had been just 255 students, with women making up just 10 percent of the degree-seekers, but by the mid-1980s, the ratio was almost even. Pictured at the December 1984 ground-breaking for CEBA's Phase I (the Engineering half of the structure), President Colbourn helps a robot—clad in UCF apparel—deliver a ceremonial bucket of sand to Chancellor Barbara Newell.

CHALLENGER, 1986. In 1981, Rockwell International displayed a month-long exhibit at the library that featured space shuttle models and photographs of various astronaut crews and missions, proving that the school's connection to the Space Coast remained healthy. But in one of the most haunting moments of the mid-1980s, the university community gathered at the Reflecting Pond to mourn the *Challenger* shuttle disaster, which had a sobering effect on all of Florida.

FLAME OF HOPE, **1987.** Mexican artist Leonardo Nierman unveiled his 10-foot bronze sculpture, *Flame of Hope*, in front of the library on September 9, 1987. Nierman's artwork is also displayed inside the library itself: his 13-by-15-foot stained-glass window, *Genesis*, is an interpretation of the creation of the world. Both pieces were created in the aftermath of Mexico City's disastrous 1985 earthquake, which destroyed the artist's studio; "Genesis" could not even escape the earthquake's aftermath unscathed . . . the glass broke during delivery and had to be returned to the artist for repairs. (Courtesy UCFAA.)

ROTC MILITARY BALL, 1988. Beginning in the shadows of the unpopular Vietnam Conflict, but bolstered by the Space Coast fascination with technology and flight, the Air Force ROTC program at Florida Tech was founded in 1972. The AFROTC soon began publishing its own yearbook, forming competitive drill teams, and organizing an annual Military Ball, with Army ROTC following shortly thereafter. The 1989 Military Ball program is pictured above. (Courtesy Michelle Romard Milczanowski.)

25TH ANNIVERSARY. For homecoming 1988, UCF was treated to stand-up comedy from rising comic Jerry Seinfeld. But for the school's 25th anniversary commencement exercises in 1988, a local hero returned to campus: astronaut John Young, the university's first commencement speaker. The number of total alumni had now rocketed past 40,000.

ALUMNI PLAZA. As part of the 25th anniversary celebrations, an Alumni Plaza outside the Administration Building was dedicated, with nameplates affixed representing alumni who had completed $1,000 pledges to an Alumni Trust Scholarship. The spirit of the campus was high; the transition from FTU to UCF was complete . . . but difficult days loomed ahead.

Five

A Campus Outgrown

Unlike the 1960s and 1970s, when each year offered a new first, the 1980s were a time when the university was fitting into its new identity, when all was settling into place like poured concrete. But while Trevor Colbourn had presided over some of the school's greatest landmark decisions, the end of the decade saw the popular president leave office. Colbourn resigned in 1989, leaving UCF in the care of Pres. Steven Altman. Student editorials from the time seemed optimistic, with one artist offering a superhero Alt-Man editorial cartoon, and though Altman made no sweeping changes, his speeches and statements had the community dreaming of another promising decade-long presidential tenure. This was important, too, because for all the school's progress under Colbourn, it still stood at a crossroads. Yes, this was definitively the University of *Central Florida*, tied inarguably with the community, nurturing a research park and several branch campuses and institutes, but UCF still had not overcome its reputation as a regional commuter school.

The same mixed feelings of excitement and uncertainty felt at UCF were felt across the United States, too, as the end of the 1980s coincided with the Soviet Union's collapse. (During Altman's inauguration week celebration, Gennadi Gerasimov—spokesman for Premier Gorbachev—actually spoke on campus.) Altman was inaugurated on April 27, 1990, delivering an address heavy with hopeful post-Soviet rhetoric. He said, "The radical transformation of Eastern Europe and the Soviet Union heralds a new world order we can hardly know today." But Altman also touched on such wide-ranging social issues as AIDS, drug abuse, and a national education agenda that ignored higher education. "All of this can make for tough times for those universities unprepared for what the future requires," he said. "We have to ask ourselves if we are ready for the next ten years."

Unfortunately, the 1990s would test this readiness, and the next seven years would prove daunting: funding would become scarce, plans scrapped, facilities outgrown, and UCF's reputation would be tarnished by scandal several times before the decade's end.

A NEW PRESIDENT. President Colbourn resigned in 1989, but he returned to campus throughout the 1990s, sometimes holding a shovel at a groundbreaking ceremony and also serving as UCF's historian, compiling an exhaustive oral history from the many individuals involved in the university's first three decades. His tenure saw the school's enrollment grow to 20,000, with nearly 800 faculty members. Additionally, UCF was using a full one-third of its 1,224 acres; Pres. Steven Altman (pictured at left with former presidents Charles Millican, left, and Trevor Colbourn, center)—and later, President Hitt—would now oversee another one-third of that land developed into an architecturally distinctive campus of its own.

SUPERBOY. President Altman saw great promise in the university's art programs and oversaw several key decisions that allowed the arts to flourish. In early-1990s Orlando, with the rising popularity of Universal Studios and Nickelodeon, the completion of Disney's MGM Studios, and the start of the NBA's Orlando Magic, some predicted that Orlando would become a new entertainment capital, "Hollywood East." The television series *Superboy* even filmed on the UCF campus.

FILM PROGRAM, 1991. While strong science programs had seemed a perfect fit in the space-minded 1960s, it was only natural that, during Central Florida's 1990s entertainment boom, UCF's academic programs mirrored the region's economic and cultural interests. With financial backing from the Florida Legislature, Charles H. Harpole left Ohio State University to begin UCF's film program. Charter enrollment was just 28 students, with the highly exclusive program capped at 60. Within the decade, UCF film students had achieved acclaim by releasing the landmark independent film *The Blair Witch Project*. Above, from left to right, are President Altman; Jack Valenti, director of the Motion Picture Association of America; and Charles Harpole. (Courtesy UCFAA.)

VISUAL ARTS BUILDING, 1991. The completion of the Visual Arts Building in December 1991 was seen as a triumph for UCF's art department, which had struggled for many years to achieve relevancy at a science-heavy university. Previously, the department had been housed within the Humanities and Fine Arts Building, a structure originally intended only as its temporary home. Drawing and painting classes had fit awkwardly into lecture halls; sinks used for printmaking had leaked, damaging floors and ceilings. Chemicals from art materials had found their way into the building's ventilation system with corrosive results. The new building would house not only offices and classrooms, but also a full art gallery.

CENTRAL FLORIDA RESEARCH PARK. From the late 1970s, Central Florida lawmakers had been considering the idea of a research park in the undeveloped lands surrounding the university. North Carolina's Research Triangle had achieved international renown by this time, and UCF (having already attracted $30 million in grants) was primed to try the concept. In November 1980, Westinghouse developed 446 acres across the street from the university, helping to attract other companies, and by 1982, the Research Park itself had its first tenant, the American Electroplaters Society. Pictured at right is Joe Wallace, Research Park's current executive director. UCF's Center for Research in Electro-Optics and Lasers (CREOL), below, a former Research Park tenant, moved in the mid-1990s into its mammoth on-campus structure, a building that has since become a symbol of mystery for undergraduates, as few may venture past the first-floor lobby. (Courtesy UCFAA.)

GREEK PARK. Greek Park, a dream since the first fraternities and sororities formed at old FTU, formally broke ground on March 6, 1983. The long-awaited community would be built in the woods outside Lake Claire on the northern edge of campus, though earlier plans had suggested a Greek lodge on the school's south end, with a second potential site also considered near the athletic practice fields. In November 1985, Zeta Tau Alpha became the first sorority to open a house, but would remain alone in the woods until the 1988–1989 academic year, when four other sororities (including Alpha Delta Pi, above) and Pi Kappa Alpha fraternity opened houses. (Above, courtesy Michelle Romard Milczanowski; below, courtesy Christa Santos.)

OLD GREEK ROW. In the 1970s and 1980s, fraternity and sorority houses were mostly located in the neighborhoods across the street from campus. Above is the original Alpha Delta Pi house. Lloyd Woosley and the Kappa Sigma brothers used two houses, one on nearby University Boulevard, as pictured below, and the other on faraway Colonial Drive. Even now, after the construction of the 12-house Greek Park on campus, several fraternities maintain houses in these neighborhoods and wait for the development of a second Greek Park—part of the original design, since delayed. (Below, courtesy Lloyd Woosley.)

PRESIDENT HITT, 1992. In 1991, President Altman resigned amid a cloud of suspicion in a local scandal, a costly setback for a school whose previous two presidents had been beloved. Quickly, however, the school found an intriguing replacement in Dr. John C. Hitt, a product of tiny Austin College in Texas, and an academic and administrative superstar at Tulane University, Texas Christian University, Bradley University, and the University of Maine (where, as vice president for Academic Affairs, he had achieved notice for engineering strong corporate partnerships). Within months of assuming the presidency, Hitt had already accepted a $1 million endowment from Martin Marietta, the largest ever for UCF. Since then, he has also established strong on-campus relationships, scooping ice cream for students in an annual tradition. He has been named both the *Orlando Sentinel's* Most Powerful Person in Central Florida and Central Floridian of the Year. (Courtesy UCFAA.)

Our plans spring from a vision of a modern metropolitan university serving the needs of the fastest growing city in the fastest growing region of Florida. We see UCF as a vital cultural and intellectual resource and as an indispensable force for economic development for all of Central Florida. We embrace the emerging ethos of metropolitan universities: we are committed to offering access to high-quality, affordable education grounded in the liberal arts; to providing the highly educated workforce a modern economy must have to flourish; to producing and transferring the scientific and technical knowledge necessary for creation and sustenance of well-paying jobs; and to developing a base of knowledge and expertise to assist with formulation of wise public policy.

To plan for the fulfillment of this ambitious mission UCF has formed a strategic planning committee. This group has done an exhaustive analysis of Central Florida's needs and our capacity to meet them. Shortly after coming to UCF, with advice and counsel from many, and after careful review of Strategic Planning Committee reports and other University and State University System planning documents, I formulated five university goals for the Year 2000. These five goals are:

- To offer the best undergraduate education available in Florida;
- To achieve international prominence in key programs of graduate study and research;
- To provide an international focus to our curricula and research programs;
- To become more inclusive and diverse; and
- To be America's leading partnership university.

I am convinced that if UCF achieves these goals, it will be America's leading metropolitan university, and, even more importantly, we will be a vital force in Central Florida's development as the nation's most dynamic, vibrant regional economy.

The key to this success is found in the final goal: it is in our ability to form partnerships. In the highly competitive world of the '90's and the 21st century, single institutions will not command the resources necessary to solve major problems. They must find common cause with individuals and other institutions of society and combine resources to address and resolve the pressing problems confronting our state, our nation and the world. Partnership is the key to achievement of UCF's goals.

Commitment to intensive, high-quality, undergraduate teaching is a staple at UCF. We intend to become national leaders in outcome-oriented teaching and learning. To accomplish this ambitious goal, we will need increased support from all sources: regents, legislators, private citizens, corporations and foundations. We will have to make creative and extensive use of emerging electronic information technologies, as well as the time-honored and tested techniques of live instruction. UCF is fortunate to have the Institute for Simulation and Training. If we use the expertise our colleagues in the Institute have lent to the armed services and to industrial clients, we can offer our students instructional opportunities of uncommon quality. We have been fortunate to attract support from key, high-tech companies. If they are willing to continue sharing their expertise and resources with our talented faculty and students, we will succeed.

FIVE GOALS. President Hitt took office on March 1, 1992, and in his inaugural address offered his "five goals," providing a much-needed spark for a university still deflated by scandal. Hitt publicized his goals endlessly (they are pictured here in pamphlet form), eventually making the five goals and the University of Central Florida nearly synonymous.

LAKE CLAIRE. Lake Claire, pictured above in the 1980s, became a hotbed of activity throughout much of that decade, the site for sprawling student parties, and (still today) an area for kayaking, volleyball, and picnicking. Though the campus party culture changed considerably when the legal drinking age rose to 21 in the early 1980s, and local bars stopped selling beer kegs on consignment, the mid-1990s saw the pine forests near this recreation area utilized for the creation of the Lake Claire Apartments, a new student housing community that—fresh in design and far from the original dormitories, which were built amidst the old brick buildings of FTU—continued the village concept of the original master plan. While attractive, these halls still would not satisfy a student population that had grown to over 20,000.

"U Can't Finish." Amidst a crippling budget crunch, the early 1990s saw the number of classes at UCF reduced and the sarcastic nickname of "U Can't Finish" take hold (a name still jokingly used today), as angry students tried and failed to secure courses required for graduation. Meanwhile, nearby Alafaya Drive was widening from two lanes to six, a sign of the residential and commercial growth coming for the entire UCF area in the 1990s. A brand-new UCF Arena even opened in 1991, pictured below, allowing for bigger basketball crowds and larger concerts and commencements. But with so many more cars and so many widened roads leading to the university (including the 408 Expressway from downtown Orlando), the parking situation worsened. Parking issues made the cover of no less than seven *Central Florida Future* newspapers in fall 1989, with frequent mention of parking-related fistfights. (Courtesy UCFAA.)

TUMULT, 1996. By the mid-1990s, the student population had outgrown the campus. Though there were positive accomplishments all around (the first issue of the Alumni Association's popular *Pegasus* magazine in 1994, left, and the construction of Pegasus Circle, below), growth-related tension spawned extreme problems. In 1996, student government was rattled by reports of leaders using student funds to purchase SUVs and football luxury boxes. President Hitt quickly shut down student government; while community leaders praised his decisiveness, many students were outraged, with some student government members bringing lawsuits against Hitt. And this would not be the only football-related scandal to rock UCF, either, as coach Gene McDowell was fired during the program's transition to Division I-A after a cell phone scandal rippled throughout the entire team. UCF was indeed a big-time university, but many wondered, could such rapid growth become the school's undoing? (Courtesy UCFAA.)

Six

PEGASUS CIRCLE
GATEWAY TO THE 2000S

In the year 1997, facilities at UCF were underprepared to handle record enrollments, the football program was ensnared in scandal, and the Student Government Association had just been disbanded. For every positive step that President Hitt had seen the university take in his short tenure, a new obstacle appeared.

The Student Union, a planned campus centerpiece that would act as a gateway to a new half of campus, was set to open spring 1997, but even this seemed uncertain. The project dated back more than a decade, as students had in October 1985 approved a referendum to build an on-campus student union, paying for it with student dollars. Initially, the plan had projected a five-year time frame, but each year new complications plagued the idea. President Colbourn, in fact, had opposed the students' top choice for a location, Pegasus Circle at the center of campus, which he had hoped would stay undeveloped. When President Altman assumed office, though, the project moved forward. Altman—citing the lack of a student union as the school's "most glaring deficiency"—approved the development of Pegasus Circle, which he found symbolic of the university's mission to keep students at its heart.

Bolstered by an $11 million bond from the board of regents, the Student Union broke ground on April 10, 1991, with completion scheduled for fall 1992. Alumni and students alike were elated. But even then nothing went according to plan, as there were construction delays, design changes, fired contractors, and a ballooning price tag. Many students never even thought they would see its completion. So frustrating was the entire process that, when the Student Union officially opened in March 1997, the university kept the occasion low-key, posting two 3-foot-tall signs in the lawn outside the empty structure, an espresso stand the only tenant inside.

But the 1997 completion of the Student Union (and the surrounding Pegasus Circle) signaled a new beginning for UCF. Though its opening had been inauspicious, the university had a new centerpiece. Now, after having faced seven years of adversity, UCF emerged in 1998 with a stunning string of accomplishments, embarking upon a decade of growth that might remain forever unrivaled in the history of America's state-funded universities.

"UNDER CONSTRUCTION FOREVER," 1996. The Student Union has grown several times since its completion in 1997, with new ballrooms and restaurants added, offices expanded, new entrances carved out of the brick exterior, new ramps and sidewalks paved, new umbrella-shaded seating added, and a new outdoor stage built into the patio. The ever-growing Student Union actually became the perfect representation of the entire university throughout the 1990s and early 2000s, as UCF earned the nickname of "Under Construction Forever."

PARKING GARAGE, 1998. In 1998, UCF opened its first parking garage. Another garage soon followed behind Business Administration, then another for the Apollo and Libra residence halls, then another for Health and Public Affairs, and by spring 2007, when a new mega-garage opened near the school's entrance (with two additional garages supporting the Athletic Village), only the most cynical students could still complain about parking difficulties. (Courtesy UCF.)

FOOTBALL RESURGENCE, 1998. The football program recovered quickly from its scandal, finishing 9-2 in its first season in Division I-A, with quarterback Daunte Culpepper taken in the NFL draft's first round. The next several years saw attendance records broken again and again. In the above picture, 50,220 watch UCF host Virginia Tech at the Citrus Bowl in 2000.

COMMUNICATION BUILDING, 1998. UCF opened its Communication Building in 1998, the curved and stylized surface designed to represent radio and television waves, beginning a new era in creative design for campus structures.

PEGASUS CIRCLE: CAMPUS GATEWAY, 2000. At the center of UCF, the Student Union (pictured above) and Pegasus Circle (below) stand like a gateway between old campus and new, between Florida Tech and Central Florida. On its southern side, asserting their red-brick-and-concrete strength, are Millican Hall, Howard Phillips Hall, Colbourn Hall, Math and Physics, the biology and chemistry buildings, and the library, each a tall and authoritative monument to classic American campuses. The Student Union, though, offers a different aesthetic: its surface pays homage to old FTU with a core of red brick, but it is softened with a lighter, sand-colored brick; the building's angles are less sharp, the windows curved, and the entrances adorned with archways. (Courtesy UCFAA.)

NEW UCF CAMPUS. Before one walks into the Student Union's front entrance, one walks among the buildings of the 1960s, 1970s, and 1980s; walk out the back of the Student Union, and one finds—stretching in every direction—a brand-new campus whose modern design mirrors the Union itself: the Health and Public Affairs buildings (above) and the Classroom Building (below), among others. All are lighter in color, less heavy in appearance, a sign of a changing university. (Courtesy UCFAA.)

CEBA EXPANSION. Even the original engineering and building complex, one of the final pieces of the old campus (conceived just after the name change to UCF), has been granted a makeover with an addition of glass-and-metal expansions completely covering some of the solid-red exterior walls. The new Business Administration II, seen above connecting with the back of the original CEBA structure, and the new Engineering II, seen below extending from the front of the original CEBA structure, both show the contrast in old and new designs. One can still view the old red-brick exterior wall from inside the new Engineering II's atrium, but now—indoors, surrounded by metal staircases and colorful artwork—one can hardly tell that it was ever an exterior wall. (Courtesy UCFAA.)

ACADEMIC VILLAGE. In 2001, President Hitt also oversaw a construction boom in student housing. The Academic Village on the school's southern end was another throwback to the original master plan: Mediterranean-style residence halls just steps from a brand-new fitness center (below), a swimming pool, and a collection of intramural fields. (Courtesy UCFAA.)

MEMORY MALL. By the early 2000s, UCF had absorbed several off-campus apartment complexes, implemented a shuttle service, and was closing roads in the center of campus for pedestrian-only use, replacing pavement with patio brick. By 2007, the sweeping greens of the Memory Mall, above, formerly a dirt parking lot, were complete, leading directly to a massive set of new residence halls and athletic venues seen below. (Courtesy UCFAA.)

ATHLETIC VILLAGE, 2007. By 2007, the Towers at Knight Plaza, pictured above, a set of residence halls constructed in the midst of the school's athletic facilities, were finally completed. These new high-rises would soon be joined by a brand-new football stadium (seen below) and arena, creating an entire athletic village on the campus's north end.

FOOTBALL ON CAMPUS, 2007. On September 15, 2007, UCF played its first game in the new on-campus Bright House Networks Stadium against the University of Texas. Spectators quickly found that by jumping in unison to Zombie Nation's popular stadium anthem, "Kernkraft 400," they could cause the stands to bounce dramatically. The swaying received national press, with ESPN commentators explaining during televised games that it was not a technical difficulty; many students enjoyed their new stadium's quirk, calling it "the trampoline." (Above, courtesy Athletics; below, courtesy UCFAA.)

ALUMNI ASSOCIATION. Founded in December 1973, the FTU Alumni Association first elected its own officers in 1977, when John D. Spencer became the first elected president of the FTUAA. The UCF Alumni Association was housed in several temporary offices throughout the 1980s and 1990s, but in 2005 finally opened its own building at the end of the Memory Mall. (Courtesy UCFAA.)

VILLAGES ACROSS CENTRAL FLORIDA. From its earliest days, Florida Tech was supposed to be a school that would transform Orlando. By the late 2000s, few could argue that it had done otherwise. The Research Park in the mid-1980s had been a major step in beginning a series of villages across Central Florida, but by 2009, the school's influence would be felt from the Space Coast, to the bright lights of International Drive (Rosen College of Hospitality Management, above), to the newly cleared land for the College of Medicine at Lake Nona below. (Courtesy UCF.)

Seven

STUDENT LIFE AT UCF

Every year, on the Friday before UCF's homecoming football game in late autumn, a stage is erected at the Reflecting Pond's concrete patio, where the Marching Knights play and cheerleaders and dance teams perform. An uncountable number of students gather at the still-green lawns around Millican Hall and the UCF Library, standing at the pond's edge, and then, all at once, they crowd into the water for the school's most popular tradition: Spirit Splash.

Perhaps no other UCF event has been more extensively publicized or photographed, but Spirit Splash is not actually a tradition as old as the school itself. In fact, it began entirely by accident. Though there are varying accounts of its origins (a 1997 story from the *Central Florida Future* reports that Spirit Splash had been in existence for 12 years), two popular accounts persist today. The first dates to 1994 and an unusually hot autumn afternoon. Throughout the 1970s and 1980s, the original homecoming parade weaved between the pond and the library, and student government sponsored Friday pep rallies at the steps of Millican Hall, with students gathering around the pond. In 1994, several students collecting pennies in milk jugs for a philanthropic contest entered into the pond to gain the crowd's attention. Using the day's stifling heat as an excuse, these students were joined in the water by many others. Nothing official resulted, though some students might have had this occurrence in mind at the next year's pep rally when student government member Bryan Farris pretended to shove Student Government Association president Miguel Torregrossa into the pond. Miguel, flinching, actually fell into the water. Seeing their elected president in the water and perhaps thinking that something official had occurred, the rest of the student government jumped into the pond, followed by hundreds of other students.

In 1995, few could have known that UCF's defining tradition had just been born. But like so many other events on this campus of 50,000, Spirit Splash has now grown into something much larger than anyone could have imagined; each year, the campus waits until homecoming week, and then, suddenly, thousands of young men and women cram into their campus landmark, splashing, chanting, and cheering.

To understand student life in the past decade, then, one must start with Spirit Splash.

THE MUCK POND, 1970. When land was first cleared for Florida Tech, President Millican insisted that the natural beauty of the site be maintained. Instead of simply leveling the forests, trees would be spared and the land itself made part of the campus design. The Reflecting Pond was initially a muck pond, an 8-foot-deep depression of brown and red water, but Millican decided that—rather than erasing it from master plans—this swamp could be transformed into the university's centerpiece.

REFLECTING POND. Florida's wet, low-elevation land could never truly be drained, but the lakes and ponds could be made attractive. Lake Claire, at the northern end of campus, was made into a recreational area, and many years later, the university created boardwalks through the cypress trees behind the Student Union, continuing a tradition of working with natural surroundings.

CAMPUS CENTERPIECE. The Reflecting Pond provided FTU's first postcard views, and though it was drained in the 1970s for commencement ceremonies and has always been a backdrop for graduation photographs, athletic team photographs, and magazine covers, it remains taboo to enter the pond (though some students, right, live by their own rules). (Below, courtesy Orientation Office.)

95

A TRADITION BEGINS. The Spirit Splash tradition started slowly. The November 7, 1995, edition of the *Central Florida Future* included a small photograph collage of that year's homecoming festivities, with a single picture of students gathered at the pond and a caption reading, "UCF students raised a ruckus during Friday's pep rally." The next milestone came in November 1997, when the name the "Spirit Splash" was first used in newspaper write-ups. The school was by that point on the verge of major change (a completed Student Union, a Division I-A football team), and the pond itself had just undergone renovations, allowing Spirit Splash to grow, as the average depth of the pond was increased, a chlorination system developed, and the concrete floor painted an algae-resistant blue. (But because the event has always taken place in November, there has never been a solution for cold water, nor for the resulting flurry of colds afterwards, termed "spirit rash" by students). (Courtesy UCF.)

SPIRIT SPLASH, 2000S. At the height of Spirit Splash frenzy, the sloping lawns falling from the library's front entrance are filled with onlookers packed together to observe the spirited ritual, the only time of year when students are allowed into the pond. Inside the pond is a mixture of willing and unwilling participants: those who come prepared with towels and extra T-shirts stacked on the pond's sidewalks, and those who are unsuspectingly soaked. Student organizations even decorate a large black fountain guard, an octagonal wood shield protecting the pond's fountain. From an early accident, Spirit Splash has become an iconic event, named the best college tradition in Florida by *Florida Leader* magazine. (Courtesy UCFAA.)

SYMPHONY UNDER THE STARS, 1981. The Reflecting Pond remains not only a focal point for student pep rallies, but also for many other endearing traditions. UCF held its first-ever Symphony Under the Stars in October 1981, with the Florida Symphony Orchestra performing at the patio and community members gathering on the grassy lawns to enjoy the concert.

VIGIL AT THE POND, 2001. At times, the Reflecting Pond also becomes a place of solemnity and reverence. Throughout UCF's 40-year history, the community has gathered at the pond in times of great distress or national tragedy for vigils, including the 9/11 attacks (pictured) and the Virginia Tech shootings. (Courtesy UCFAA.)

HOMECOMING, 1979. For the first-ever UCF (not FTU) homecoming in 1979, the theme was Knights on Broadway, and the parade passed along the paved road between the Reflecting Pond and the UCF Library. A band also joined the parade for the first time: Orlando's Jones High School band.

HOMECOMING 1980. In 1980, there would be two homecoming weeks, the first in January for basketball season and the second in November for football season. Students would also conduct two homecoming parades, one on campus on Friday afternoon and the other on Saturday morning in downtown Orlando.

99

Marching Knights. In 1980, one year after the football program's inception, the Marching Knights began practice. Backed by $30,000 from student government, director Jerry Gardner (center) had just three months to assemble a roster before the 1980 football season began, and he scoured university files to find students with marching band experience. With Troy Driggers selected as the first drum major, "the pride of Central Florida" took the field for the first time on September 27, 1980, wearing T-shirts and blue jeans until they could afford uniforms. Following Driggers's tragic death in 1982, the band's original practice field was named in his honor, seen below, and the uniform adorned with a black-and-gold pin.

CITRUS BOWL PERFORMANCES, 1980s. Throughout the 1980s, the band alternated uniforms constantly, wearing everything from beachwear to Wild West costumes (pictured at right in 1981). The Beach Boys (pictured below) played at the Citrus Bowl for UCF's 1986 homecoming, helping to set a then-record attendance of 23,760.

CHURCH STREET, 1979. The university's relationship with downtown Orlando strengthened with the start of UCF football at the Citrus Bowl. Church Street Station, a strip of popular downtown restaurants and bars, advertised heavily in the first football programs. Cheerleaders led raucous pre-game pep rallies downtown as well, including the pictured 1979 pep rally at Rosie O'Grady's. For more than a decade, the homecoming parade even weaved among the skyscrapers of downtown Orlando, passing crowded Church Street bars at 10:00 a.m. After the 2007 construction of an on-campus stadium, though, the parade returned to UCF. (Left, courtesy Linda Tomlinson.)

CHEERLEADING. Cheerleading has always had a strong tradition at UCF. In the 1970s, the team was built around basketball season, but after 1979, cheerleading became more closely associated with football. The UCF cheerleaders would see their greatest success in the next century, with national titles in 2003 and 2007, 14 finishes in the top 10 in 16 years, and a season of WE's *Cheerleader U* television show dedicated to the team's daily routines.

MASCOTS. Throughout the 1980s, the university mascot underwent several incarnations, from an early plastic-faced creature called both Sir Knight and Sir Wins-A-Lot, to a Disney-esque villain named Puff the Dragon, to a googly-eyed cartoon named Mack the Knight, who was unveiled for the 25th anniversary. Kathi McCutheon (pictured) was the first knight to ride a horse (which she supplied herself) at football games; late in the 1980s, the horses and riders of Medieval Times—a staple of the Orlando entertainment industry—also performed a pregame show. The original Knightro, who became the school's lasting mascot, was unveiled on November 19, 1994, with cheerleader Trey Gordon serving as the first Knightro. With UCF's logo update in 2007, Knightro's costume saw significant changes. (Below, courtesy UCF.)

FRATERNITY LIFE. Though the FTU administration had banned fraternities from campus before classes ever began, resourceful students organized social clubs as early as 1968, with the intention of later affiliating with national fraternities. The strong demand for fraternity and sorority life led administrators to rethink their position; very quickly, Pi Kappa Epsilon formed as the first fraternity in 1969 (eventually chartering as the national Pi Kappa Alpha). The Tech Club actually became the first national fraternity on campus when it chartered as Kappa Sigma in 1970. Greek life quickly became integral to early student life, fielding most intramural teams, participating heavily in campus events even while the school was dense with disinterested commuter students, and working the phones to raise funds for the Alumni Association during early phone-a-thons. (Above, courtesy Greek Affairs.)

SORORITY LIFE. FTU's first sorority was Tyes (now Pi Beta Phi) in 1968, followed in the next decade by five other national sororities. The total membership for Greek life grew exponentially in the 1980s and 1990s, with dozens of new fraternities and sororities (including the entire Divine Nine of the National Pan Hellenic Council), and today Greek life remains one of the most popular forms of student involvement at UCF. (Both courtesy Greek Affairs.)

GREEK WEEK. Greek Week has been a campus tradition since the 1970s, and while events have changed (early competitions between fraternities and sororities included keg tosses, chariot races, and even drinking games), the week has traditionally been held each spring. Above, early local fraternities compete in a sack race; below, Tri Delta aims to win the 1982 Mattress Race.

THE LION BURNING. Perhaps the most endearing of fraternity traditions at UCF is the Sigma Alpha Epsilon lion burning on the eve of homecoming. Throughout the year, the gold lion in the fraternity house front lawn is tagged by sororities, spray-painted as Santa for Christmas or red, white, and blue for Memorial Day (and during both Gulf Wars, in camouflage colors). Before homecoming, students and alumni gather, coat the lion in diesel-soaked towels, set the statue ablaze, and watch the flames consume the year's accumulated paint. (Both courtesy Joe Maclellan, Chad Gottlieb, and Sean O'Shaughnessy.)

Eight

THE ATHLETIC VILLAGE

On December 1, 2007, tens of thousands of UCF Knights fans walked the campus Memory Mall, a vast grassy quad lined with tents and tailgaters, then continued down the Legacy Walk—a brick walkway etched with donor names—and into Bright House Networks Stadium for the Conference USA football championship game. The stadium had opened only months prior, allowing the university to host football on campus for the first time ever.

But the stadium's opening was significant for another reason: it anchored a bold new village on campus, now finally complete. This Athletic Village also included a brand-new arena for basketball games, graduations, and concerts (it had also opened that fall, marking the first time that a university had opened a major arena and stadium in the same year). An entire main street of restaurants, bookstores, and shops (Knight Plaza) lined the sidewalks around the arena and stadium, all of it living in the shadows of the massive Towers, the university's newest residence halls. The village concept of the university's original master plans had indeed been realized, though on game day, this Athletic Village seemed less a village and more a mini-city, with over 45,000 UCF supporters walking its streets together.

And on championship Saturday, in front of a packed stadium, the UCF Knights—led by quarterback Kyle Israel and running back Kevin Smith (who finished the day as the nation's leading rusher for the season and was second in NCAA history for single-season yardage)—defeated the Tulsa Golden Hurricane 44-25, securing their first-ever football championship and sending UCF to the Liberty Bowl, their second bowl game ever. As with so much else at the nation's sixth largest university, the years 2007–2008 seemed a culmination: all sports were under the umbrella of a single conference, with each finally boasting its own venue in the Athletic Village, and several now displaying Conference USA championship banners.

But, of course, all had not happened overnight. The journey toward that moment in Bright House Networks Stadium, when coach George O'Leary took the microphone and accepted an invitation to play in the Liberty Bowl, had been 40 years in the making.

FRANK ROHTER, 1969. In Florida Tech's early years, students and faculty alike formed recreational league teams, but it was not until 1969 that the athletic program was approved and the university began establishing club teams. Dr. Frank Rohter, who had previously coached football, swimming, and water polo in California, took the challenge of establishing athletics at FTU. In the beginning, Dr. Rohter had no scholarships to work with, and he focused on slow, smart growth, beginning only those sports that made financial sense for the university, finding clever ways to grow the school's athletics. For tennis courts, Dr. Rohter convinced the Physical Plant to pave a new parking lot with the dimensions of a tennis court, where the team would then string up its net. And coach Gerry Gergley (below right), pictured with Dr. Rohter (below left), was able to start a wrestling team at FTU, despite a weak interest in wrestling throughout Central Florida, simply because it was a low-cost program. (Courtesy Frank Rohter.)

FACULTY COACHES. Because the original athletic department was part of the College of Education, with coaches hired as tenure-line faculty, Dr. Rohter sought to establish healthy relationships between faculty and coaches. In the mornings, the coaches dressed in shirt and tie to teach, then changed in their cars to head to practice. Coaches also created their own season schedules and maintained their own budgets; with little money for travel, most opponents were within an hour's drive, generating intense rivalries with local schools. FTU, in fact, became a charter member of the Sunshine State Conference, composed of Rollins College, Florida Southern College, Biscayne College, Eckerd College, and St. Leo College. Pictured above from left to right are four of FTU's first NCAA coaches: tennis coach Lex Wood, a South African Olympic star; basketball coach Eugene Clark; wrestling coach Gerry Gergley; and baseball coach Doug Holmquist. Early Florida Tech athletes were not on scholarship and received few privileges, and in the small-school environment of the 1970s, students and faculty alike rallied around their scrappy teams whom they viewed as classmates and peers. (Courtesy UCFAA.)

WRESTLING. Early teams were often willed into existence by dedicated coaches. Coach Gerry Gergley (bottom, center) convinced Dr. Rohter that wrestling could succeed at FTU despite limited resources; during his initial job interview, Gergley pulled a wrestling mat from his car to convince Dr. Rohter that this was the only resource wrestlers would need. The team practiced in the cafeteria, stacking chairs and pushing aside tables to clear room for mats. Sometimes, the team even practiced at Lawton Elementary. Such strain bred a fierce wrestling team, with tiny FTU beating Notre Dame University, Florida State University, and the University of Georgia.

SOCCER. Soccer (pictured here in 1981) began in the same scrappy tradition as other sports at FTU, when Hungarian-born special collections librarian Norbert St. Clair held practices in the fields behind the library, using pine trees and coats for goals. Quickly, the program achieved success, with its first national ranking by December 1974 and goalkeeper Winston DuBose making school history by becoming FTU's first All-American.

BASKETBALL, 1969. With coaching legend Eugene "Torchy" Clark at the helm, basketball, pictured at right in 1969 and below in 1978, became the hot-ticket sport throughout the 1970s, but limited resources forced Clark's teams to practice at nearby Oviedo High School, the Naval Training Center gym (surrounded by boxing rings and other exercise equipment), and nearly a dozen other local facilities. Clark and his wife even washed the players' uniforms. The team played its home games off campus—the first, a 93-71 win over Palm Beach University, came at Winter Park High School—before opening their home court in the Education Gym on January 15, 1977. The gym, packed for this home opener, seated 2,456, as Rollins College defeated FTU 58-53. (Right, courtesy UCF.)

TORCHY CLARK. Torchy Clark, known for his fiery personality, led the basketball team to Sunshine State Conference titles in each of the conference's first three years of existence and five conference championships from 1976 to 1983, with annual top 10 rankings and frequent trips to the NCAA Division II Tournament. The team even posted a 24-game win streak in 1978, rising to No. 2 in the national rankings. Most important, Clark's teams performed exceptionally against crosstown rival Rollins College and the University of South Florida, who by the late 1970s and several losses to FTU, informed Clark that their growing program would no longer play such small schools (though the series resumed after Clark retired). He is pictured at left with President Colbourn, accepting a plaque honoring his 200th victory. Bo Clark, below, Torchy's son, achieved star status in the late 1970s as well, averaging 28.7 points per game in 1977, with a 70-point effort against Florida Memorial University.

BASEBALL. FTU baseball (known as the Goldsox during its early club sport years) faced the same financial constraints as other sports, with the team practicing in parks across town, including those surrounding Tinker Field downtown. Coach Doug Holmquist would sweep the dugouts of collected trash before practice. The baseball team, though, has always been a bright spot for athletics. In the 1979 season alone (their first year as UCF), the team posted a 27-17 record, finishing first in the Sunshine State Conference, advancing to postseason play, and breaking 45 individual and team records that single season. Shortly thereafter, coach Jay Bergman took over the team, guiding them through 26 years and an overall record of 994-594-3. Below, the baseball team is pictured in its first UCF uniforms.

THE CREW LEGACY. Established in 1971 by Dennis Kamrad, the four-man crew team earned FTU its first national championship in 1974 by traveling to Philadelphia and winning the U. T. Bradley Cup. Not only was this the first all-Florida crew to win a national championship, but this was the first-ever victory for a coed team (with Alison Pacha as coxswain, above). Just a few years later, after a split into men and women's teams, women's crew also won a national championship. By 2008, crew teams had won 16 national championships, a stretch of victories made all the more impressive by the fact that early on they were a club sport, without athletics funding. Coach Kamrad had volunteered, with the team paying its own travel expenses and maintaining its equipment at Lake Pickett.

116

VOLLEYBALL, 1978. Volleyball became the first women's intercollegiate sport in 1975, posting a 15-1 record and four tournament championships in just their first two weeks, establishing a strong winning foundation for women's athletics. But because resources were still limited, 10 volleyball players, in order to earn scholarships, also had to play for the newly formed softball team the following spring. Volleyball also became the first women's sport at the university to advance to any national finals tournament, when under coach Lucy McDaniel, they achieved a 44-15 record in 1976. In 1977, they improved again, with a fourth-place Division II finish. But by 1978, they had their strongest achievement: the women's volleyball team had compiled a perfect 55-0 record, complete with a victory on December 9, 1978, in the AIAW Small College National Volleyball Championship (the early women's equivalent to the NCAA).

WOMEN'S SOCCER. Other women's sports also started strongly. In each of its first two years of competition, the women's soccer team advanced to the national championship game, losing both times to the University of North Carolina (and in 1982, losing at St. Clair Field on the UCF campus before 1,100 fans). Michelle Akers, below in 1985, became a superstar in the 1980s, leading the women's soccer team and playing on the gold medal–winning U.S. Olympic Team.

FOOTBALL, 1979. Just months after Pres. Trevor Colbourn assumed office, plans were underway to begin a football team. The athletic department had a solid foundation, and the city of Orlando had no major professional sports. Dr. Jack O'Leary—after becoming the school's first full-time athletics director in the 1976–1977 academic year and overseeing the successful transition years from Florida Tech to UCF, during which basketball, baseball, men's soccer, and men's tennis all won Sunshine State Conference titles—seemed the perfect man to guide the football program's development. Don Jonas, a former Pennsylvania State University quarterback, an MVP for the Canadian Football League's Toronto Argonauts, and a star on the short-lived Orlando Panthers organization, was hired as the school's first football coach (pictured above left with President Colbourn), though he and his entire coaching staff (seen below) served as volunteers. At the time, Jonas worked for the City of Orlando, and it was only because he convinced his superiors that UCF football could generate money for Orlando Stadium that he was able to spend workdays coaching the team.

FIRST PRACTICES. Nearly 180 candidates attempted to walk on to the brand-new UCF football team, some of them local high school players without scholarship offers elsewhere, some of them cast-offs, some of them bouncers or fighters looking for action. Often, they would have less experience and fewer resources than their opponents. There were no on-campus locker rooms; players washed their own uniforms and sometimes practiced in sandspur-thick fields never intended for football. But the first football team set a tradition by playing gritty ball, never surrendering despite being outmatched. Pictured below, the 1979 football team poses for a team shot.

ST. LEO, 1979. The program started slowly: first, in Division III, against St. Leo College. Coach Jonas implored the team to remember that future generations of football players would take their cue from what happened on September 22, 1979, when the Knights took the field for their first game. The team, however, encountered two major difficulties before even stepping off the bus. First, a stomach virus raged among the players (the result of the pregame meal). Next, hurricane conditions were building in the Gulf of Mexico, and St. Leo considered canceling the game. But coach Jonas demanded they play, and in the first quarter, quarterback Mike Cullison connected with Bobby Joe Plain, who sloshed 13 yards for UCF's first-ever score (above). Over 1,000 UCF fans came to watch the Knights defeat St. Leo 21-0, all of them soaked by game's end. Pictured at right, cheerleaders Barbara Emerson and Tonya Carroll huddle under an umbrella.

THE FIRST SEASON. UCF used Orlando Stadium (at times, named the Tangerine Bowl and later the Citrus Bowl) for almost 30 years, with the first season tickets starting at just $13. Early seasons, with a theme of Saturday Knights Live, saw home games played in the evenings. The first season proved successful, with opening night drawing 14,188 fans and the four-game season averaging 11,240 fans (both Division III records). After an exciting home opener—winning 7-6 over Fort Benning on Tom Hungerford's extra point—the Knights finished the season 6-2. UCF football's second season, which opened at home against St. Leo College as pictured below, ended with a 4-4-1 record, and senior defensive back Tim Kiggins becoming the program's first All-American. In these early years, the very first fan tradition also formed: the Saturday Night Herd, a group of white-shirted fans in one end zone, clanged cowbells throughout football games. (Left, courtesy Athletics; below, courtesy the Michael O'Shaugnessy Archives.)

DIVISION II FOOTBALL. Eager for positive publicity as UCF transitioned into Division II football, athletic director Bill Peterson made a bold hire in December 1982: for UCF's fifth football season, Lou Saban—a former coach with the Buffalo Bills, the Boston Patriots, and the Denver Broncos—would attempt to build the Knights into a winner. UCF invested a great deal in its new coach . . . but such daring carried with it great risk. Saban went 5-6 in his first season, and in his second season, after a 1-6 start, he resigned, leaving the program in near financial ruin. Though there was talk of disbanding the football program, several key fund-raisers, including OJ's Gate Crasher fund-raiser in 1984, an auction that generated more than $200,000 from O. J. Simpson memorabilia (among other things), seen above, and contributions from Burt Reynolds, pictured below with Peterson and President Colbourn, helped keep athletics afloat.

123

FOOTBALL RESURGENCE, 1985. Gene McDowell (left) was hired in 1985 as athletic director and head coach of football, and he set about resurrecting the athletic department. McDowell waived his salary as athletic director and had uniforms and equipment donated by Florida State University's Bobby Bowden. The situation was dire, though. Local support was waning. But in 1985, on the brink of a fifth straight loss to rival Bethune-Cookman College (a game dubbed the Mayor's Cup), and in front of a record 21,222 fans, Gene McDowell led his team to a 39-37 victory over BCC. Eddie O'Brien kicked a 55-yard field goal as time expired, winning the game and likely saving the football program. (Left, courtesy Athletics.)

GLORY YEARS. With much-improved play, McDowell's teams continued to set attendance records in the late 1980s, even notching their first postseason win in 1987 against Indiana University of Pennsylvania. The 1988 team received a No. 2 ranking, and the Citrus Bowl—now consistently drawing 30,000 fans—became the most intimidating venue in Division II. UCF finally entered Division I-AA in 1990, hosting a playoff game in its first year and growing into a dominating program in the early 1990s. Throughout the 1980s and 1990s, the student section of the stadium became a multicolored checkerboard, as fraternities and sororities wore their organizations' jerseys and stood in blocks. (Some students maintained that coach McDowell, a Lambda Chi Alpha alumnus, was encouraged to see a strong showing of green jerseys, which they called "the green wave"). (Below, courtesy Michelle Romard Milczanowski.)

125

USF RIVALRY. The University of South Florida in Tampa remains UCF's most hated rival. Separated by 90 miles, their founding dates less than 10 years apart, and their missions as metropolitan universities strikingly similar, the animosity began with academics, when Charles Millican resigned as USF's dean of business to become UCF's first president, also recruiting Charles Micarelli (USF's chairman of Modern and Foreign Languages) to join him. In the 1970s, after the UCF basketball team began a streak of victories against USF, the Bulls discontinued the series. Similarly, USF—in its football program's first years—refused to play UCF, beginning a series only after UCF suffered a worst-ever 0-11 season in 2004, then ending the series in 2008 after a narrow overtime win. (Courtesy Athletics.)

DIVISION I-A, 1996; CHAMPIONS, 2007. UCF moved to Division I-A on September 1, 1996, marking the first time that a university had played football in four different divisions. Quarterback Daunte Culpepper (right) helped UCF make headlines at the Division I-A level, as a school record of 41,827 packed the Citrus Bowl to watch UCF beat the University of Idaho in 1997. In 2004, amidst much fanfare (including cardboard cutouts displayed across campus), highly touted coach George O'Leary was hired to rebuild the struggling football program. Though that season ended with an 0-11 record, O'Leary led the Knights back to victory in 2005, beating Marshall University at the Citrus Bowl (with fans swarming the field to tear down the goalposts) en route to an 8-5 season, a berth in the first-ever Conference USA championship game, and a berth in their first-ever bowl game, the Hawaii Bowl. And in 2007, the football team would win Conference USA in front of their home crowd at Bright House Networks Stadium on campus, pictured below. (Courtesy UCFAA.)

DISCOVER THOUSANDS OF LOCAL HISTORY BOOKS
FEATURING MILLIONS OF VINTAGE IMAGES

Arcadia Publishing, the leading local history publisher in the United States, is committed to making history accessible and meaningful through publishing books that celebrate and preserve the heritage of America's people and places.

Find more books like this at
www.arcadiapublishing.com

Search for your hometown history, your old stomping grounds, and even your favorite sports team.

Consistent with our mission to preserve history on a local level, this book was printed in South Carolina on American-made paper and manufactured entirely in the United States. Products carrying the accredited Forest Stewardship Council (FSC) label are printed on 100 percent FSC-certified paper.

MADE IN THE USA